P9-EEM-885

Art of the Sixties

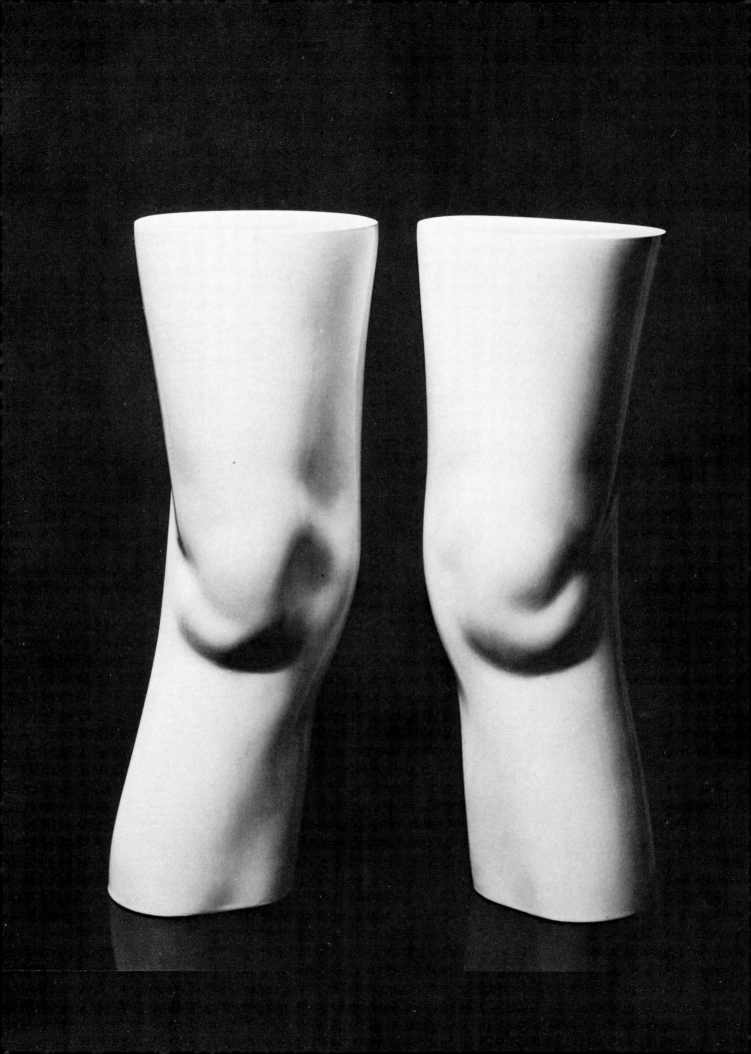

Art of the Sixties

HUGH ADAMS

Phaidon · Oxford

Phaidon Press Limited, Littlegate House, St Ebbe's Street, Oxford

First published 1978
Published in the U.S.A. by E. P. Dutton, New York
© 1978 Phaidon Press Limited
All rights reserved

ISBN 0 7148 1824 0

Library of Congress Catalog Card Number: 78-56662

No part of this publication may be reproduced, stored in
a retrieval system or transmitted in any form or by any
means, electronic, mechanical, recording or otherwise,
without the prior permission of the copyright owner

Printed in Great Britain by Waterlow (Dunstable) Limited

LIBRARY

JUL 8 1982

UNIVERSITY OF THE PACIFIC

395402

Frontispiece: 1. Claes Oldenburg (born 1929): *London
Knees*. 1966. Plastic, height: 37.6 cm. (14¾ in.) Cologne,
Ludwig Museum

4

List of Plates

Bibliography

This bibliography concentrates on general works and ignores catalogues for individual artists' exhibitions and monographs. Many catalogues are still in print and available from such places as the Tate Gallery, London, and the Museum of Modern Art, New York. The journals: *Art and Artists*, *Artforum* and *Studio International* are fertile ground for students of the period.

BOOKS

Alloway, Lawrence, *American Pop Art*, Macmillan, N.Y., 1974.

Barrett, Cyril, *Op Art*, Studio Vista, London, Viking Press, N.Y., 1970.

Brett, Guy, *Kinetic Art*, Studio Vista, London, Van Nostrand Reinhold, N.Y., 1968.

Callas, Nicholas & Eileen, *Icons & Images of the Sixties*, Dutton, N.Y., 1971.

Coutts-Smith, Kenneth, *The Dream of Icarus*, Hutchinson and Co., London, 1970.

Creedy, Jan. (ed.), *The Social Context of Art*, Tavistock Publications, London, 1970.

Davis, Douglas, *Art and the Future*, Thames & Hudson, London, 1973.

Geldzahler, Henry, *New York Painting & Sculpture 1940-1970*, Pall Mall Press, London, 1969.

Hansen, Al, *A Primer of Happenings and Time-Space Art*, Something Else Press, N.Y., 1965.

Kaprow, Allan, *Assemblage, Environments and Happenings*, Abrams, N.Y., 1961.

Kozloff, Max, *Renderings: Essays on D. Smith, Johns, Rauschenberg, Kienholtz, Stella & Noland*, Studio Vista, London, 1970.

Kultermann, Udo, *Art Events and Happenings*, Trans. J. W. Gabriel, Matthews, Miller, Dunbar, London, 1971.

Lucie-Smith, Edward, *Movements in Art Since 1945*, Thames and Hudson, London, 1969.

Nuttall, Jeff, *Bomb Culture*, MacGibbon & Key Ltd., London, 1968.

Popper, Frank, *Art-Action Participation*, Studio Vista, London, 1975.

Rose, Barbara (ed.), *Readings in American Art 1900-1975*, rev. edn., Praeger Press, N.Y., 1975.

Rosenberg, Harold, *The Tradition of the New*, Thames and Hudson, London, 1962.

Rosenberg, Harold, *The De-Definition of Art: Action Art to Pop to Earthworks*, Secker and Warburg, London, 1972.

Tomkins, Calvin, *Ahead of the Game* (Published in U.S.A. as *The Bride & the Bachelors*), Penguin, 1968.

Wolfe, Tom, *The Painted Word*, Bantam Books, New York, 1976.

EXHIBITION CATALOGUES

American Sculpture of the Sixties, L.A. County Museum of Art, Los Angeles, 1967.

Lucie-Smith, Edward, *British Painting & Sculpture 1960-1970*, Tate Gallery, London, 1970.

Two Decades of American Painting, Museum of Modern Art, N.Y., 1966.

ARTICLES AND REVIEWS

Bannard, Walter Darby, 'Notes on American Painting in the 60's, *Artforum* (January, 1970).

Buren, Daniel, 'Is Teaching Art Necessary?' *Galerie des Arts* (September, 1968).

Clay, Jean, 'Art Tamed and Wild', *Studio International* (June, 1969).

Clay, Jean, 'Painting a Thing of the Past', *Studio International* (July-August, 1967).

Cork, Richard, 'Alternative Developments': essay in *Arte Inglese Oggi. Part 2 1960-76*, Milan, 1976.

Fine Artz, 'A Fine Artz view of Teenage Cults', *Ark*, xxxvi (Summer, 1964).

Glauber, Robert, 'The Effect of American Violence on American Art', *Skyline, Bulletin of the Museum of Contemporary Art, Chicago* (July, 1968).

Greenburg, Clement, 'Avant Garde Attitudes: New Art in the 60's, *Studio International* (April, 1970).

Harrison, Charles, 'Against Precedents': catalogue introduction for *When Attitudes Become Form*, I.C.A., London, *Studio International* (September, 1969).

Kozloff, Max, 'Happenings: The Theatre of Mixed Means', *The Nation* (July 3rd, 1967).

Lippard, Lucy and Chandler, John, 'The De-materialization of Art', *Art International* (February, 1968).

Morris, Lynda, 'What Made the Sixties' Art so Successful, So Shallow?', *Art Monthly* (October and November, 1976).

Popper, Frank, 'Tinguely: Inspired Anarchist', *Art and Artists* (August, 1966).

Read, Sir Herbert, 'The Disintegration of Form in Modern Art', *Studio International* (April, 1965).

Sandler, Irving and Rose, Barbara, 'The Sensibility of the Sixties', *Art in America*, LV. No. 1 (January-February, 1967).

Sylvester, David, 'Art in a Coke Climate', *Sunday Times Colour Magazine* (January 26, 1964).

Varley, William, 'Art as Art as Art etc.' Originally published in *Stand Magazine*, No. 1 (1966), republished in *Innovations*, (ed. B. Bergonzi), Macmillan, London, 1968.

Art of the Sixties

The nineteen-sixties possess a perfect *gestalt*, the beginning and end coincide exactly with cultural shifts of such significance as to merit their isolation as a suitable period for analysis and comment. Distilling the essence of the art of the period, and placing it within its social and historical context, whilst also managing to convey the mood of the time, is, however, no mean task.

Hugely diverse sources of complex, fragmented, and often conflicting evidence conspired to obscure events and the truth concerning them. This immensely increases the difficulty of unravelling, and lucidly presenting, important elements of art in their proper context; but the task is rendered even more difficult by the fact that art occurrences became, not only increasingly prolific, but often less recognizable and more ephemeral than hitherto. The sixties and early seventies mark the rise of unorthodox forms of expression and an accompanying willingness, anxiety even, on the part of many artists to comment, sometimes at length, on their work. To ignore this contribution would plainly be churlish, particularly as the very nature of the art work has come into question. Consequently I have given some prominence to artists' statements, and also to those of critics. At a time when more was written about art than ever before, and when criticism, particularly American, has been maintained (by Tom Wolfe in *The Painted World*) to have become

more important than art itself, it seems right to present it at first hand.

Placing almost exclusive emphasis on British and American developments is not simply chauvinism: for the art of the sixties was shaped by two cities—London and New York. By the early sixties New York had taken the place of Paris as art capital of the world; shared affluence and a common language dictated that London follow. The vigour and freedom of the British art-educational system produced a wealth of gifted graduates. Fashion designers in particular made an impact on the international scene at the time when ex-Royal College of Art painting students took the art world by storm. Thus was the London-New York axis consolidated. Since most of what was significant in sixties' art was initiated in either one or the other place, and only imitated elsewhere, albeit rapidly, one is justified in concentrating on them.

The forces which contributed to the development of a distinctively sixties' mode of expression were more diverse, also more powerful, than those affecting the consciousness of previous generations. Thus the sixties was a period of pluralism almost unique in the history of art. Never before had there been such tolerance, or such great variation both in style, and in what was admissible art practice. This significant aesthetic shift was a result of the repudiation of immutable categories for expression, and impatience with

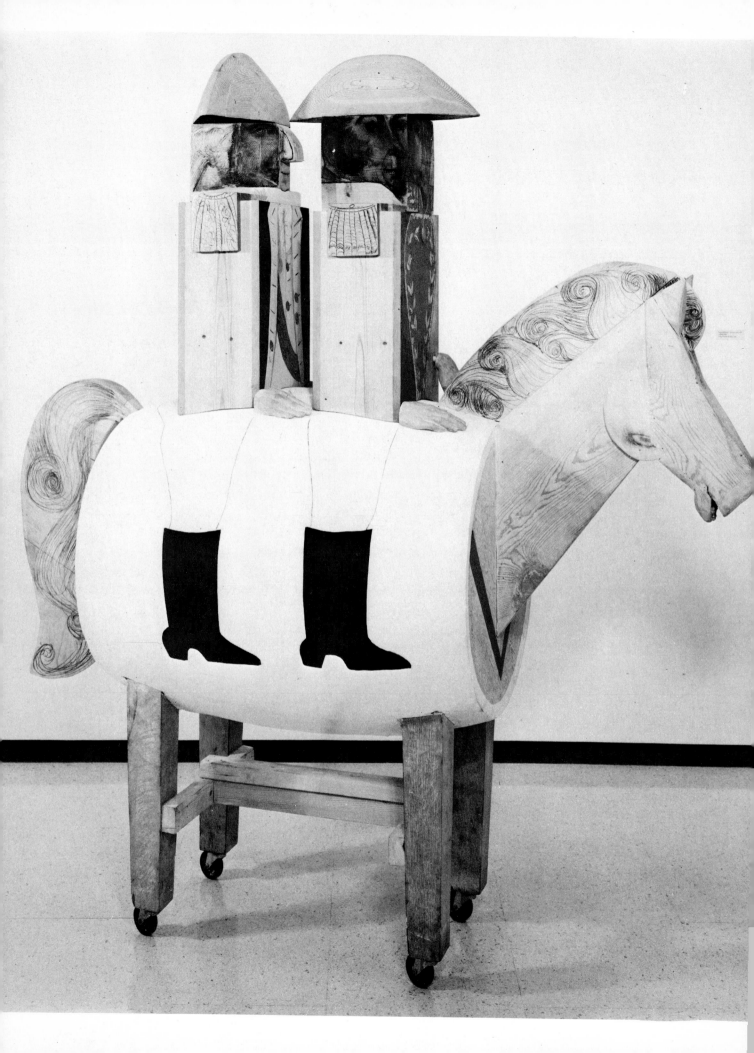

traditional critical values. The challenge to these is the greatest success of the sixties.

Sad to say receptivity to change was often born not of a conviction of its intrinsic rightness, but of the determination of a whole generation of tastemakers—critics, museum directors and patrons—not to be 'wrong' in their historical judgement. Walter Darby Bannard, in what admittedly is an extremely jaundiced view, wrote of the critics' fear of being wrong furthering a situation in which many different styles co-existed. They lived 'with the spectre of the critic who denounced the art which proved to be important—and these are the key words of the sixties, the all-purpose catchphrase of the eyeless art public: *new* and *important*'. Since newness was different and by extension important and generative, assimilation and consolidation of a multiplicity of styles was inevitable: 'their own indecision sustains the persistence they seek. And so we have the spectacles of mighty art institutions like the Museum of Modern Art loaded to the hatches with chi-chi junk like Marisol sculpture, hideous Wesselman paintings, the grim idiocy of Lucas Samaras, all kinds of bobbing, clicking, flashing and wiggling things, and exhibitions of photographs of gigantic earth and sky 'works' which are as destructive as they are silly.' The aesthetic of newness received its consecration in *The Tradition of the New*, Harold Rosenberg's influential collection of essays. This created an awareness of various unprecedented social phenomena and a whole vocabulary of soft-sociological descriptions—'hidden persuaders', 'ad-mass', 'status-seekers', 'mass-culture', 'kitsch', 'the new', and others, which entered the language, becoming popular

2. Escobar Marisol (born 1930): *The Generals*. 1961-2. Various materials, 221 × 193 × 72.4 cm. (87 × 76 × 28½ in.) Buffalo, N.Y., Albright-Knox Art Gallery; gift of Seymour H. Knox

expressions, not among academics solely, but among journalists, art students and 'ad-men'. Sociology, the tool of which this newspeak became, boomed as an academic discipline; *young* interpreters and commentators on the new society ascended rapidly to chairs in provincial universities and polytechnics. Significant advances in legislation, particularly in Britain, together with a more permissive climate, ensured that they had plenty to study.

The desire for the new created, and the new affluence permitted, a plethora of new vehicles for artistic expression. The results of recent technological innovation were incorporated into art and rapidly exploited by exuberant and inventive practitioners. Larry Bell, in an essay on Warhol in *Artforum*, points out that it was in the sixties for the first time that an older generation had an influence on a younger before its own philosophy was fully resolved. Others wrote of the absence of an avant-garde. With disciples following so hard on the heels of the innovators a consequent lack of direction and tendency to indulge in novelty for its own sake is not surprising, but there was also a discernible willingness to suspend an intellectually rigorous, critical approach on the part of artists and commentators alike.

Despite the movement away from the 'art-object', which gained momentum in the late sixties (receiving its first celebration in the 'Nine at Castelli' exhibition in 1968, and its establishment recognition in the Whitney show: 'Anti-Illusion: Procedures/Materials' in mid-1969), the majority of artists who made an impact in the period were producing work within the traditional categories of painting and sculpture. Attempts to widen artists' options, introduce new media, and gain their significant acceptance (despite the fact that they were often lineal descendants of earlier 'alternative modes') made comparatively small headway until the late sixties when there was a sudden burgeoning of interest.

9

Michael Heizer's attitude to new forms is fairly typical, an aesthetic, rather than political, impulsion away from 'traditional' means of expression: 'After I had been in New York a couple of years, I saw art there as really dead . . . a lot of things had been killed off at the same time because the forms themselves were coming into question.' This does suggest a desire for 'newness' as well as the erosion of the former exclusive nature of art.

It is doubtful whether there was a widespread and conscious attempt to make art more accessible in the early and mid-sixties; after all, in his essay *The Public is Not Invited*, Tom Wolfe identified constituents of the 'art world' as approximately 10,000 souls: 'the public that buys books in hard cover and paperback by the millions, the public that buys records by the billions and fills stadiums for concerts, the public that spends $100 million on a single movie—this public affects taste, theory and artistic outlook in literature, music, and drama, even though courtly élites hang on somewhat desperately in each field. The same has never been true in art.' It is the people of the 'art world' who are the taste makers and buyers, it is they whom the artist addresses. The rest 'whose glorious numbers are recorded in the annual reports of the museums . . . are merely tourists, autograph seekers, gawpers, parade watchers.' That the numbers of these people attending galleries and art events grew enormously during the sixties is beyond doubt; there were many commentators prepared to dispute that numbers alone meant anything: 'the more Americans show an interest in music, dance, painting or poetry, the more certain it is that the criteria of excellence erected by the cultivated élite will be trampled by a mob of eager ignoramuses,' wrote Alvin Toffler. Dwight Macdonald, the doyen of the élitists, agreed: 'while High Culture could formerly address itself only to the *cognoscenti*, now it must take

the *ignoscenti* into account . . . if there were a clearly defined cultural élite, then the masses could have their *Kitsch* and the classes could have their High Culture.' Paradoxically there were those who actually denied that there even was a 'culture explosion'. Harold C. Schonberg's *Saturday Evening Post* article, 'The Culture Explosion is Phony,' criticized those who 'brag that U.S. culture is booming'; unfortunately he contradicted an earlier piece he had written for the *New York Times* (of which he was resident music critic) when he said that 'the last decade has been virtually a renaissance, and may be recognized as such in history'. However, the fact was that 'The devotees of art have grown from a lonely handful to an army,' and Toffler traced the aesthetic, sociological, and economic consequences of that fact for the arts as a whole. Whether the artist himself cared about extending the art audience is a moot point but clearly the incorporation of popular imagery into much of the work fostered the idea that it was so. Roy Lichtenstein put it into perspective: 'There may be a greater and more sophisticated art audience than before, but this audience is very small, and the great public for art probably compares with the public for chemistry.' The divorce between artist and public which began in the age of specialization was not significantly bridged in the electronic age simply because the artist chose to work in, or with, the mass-media. In fact the very discussion of this problem began to form part of art practice, especially in England. Sadly the resultant work declined either into formalism or into an analytical concern with style.

The cerebral approach to the problems associated with popular culture distinguished British artists from their American counterparts, whose attitudes tended to be either neutral towards their sources, or celebratory. In tracing the nascence of British Pop Art,

3. Roy Lichtenstein (born 1923): *Little Big Painting*. 1965. Oil on canvas, 173 × 203 cm. (68 × 80 in.)
New York, Whitney Museum of American Art; gift of the Friends of the Whitney Museum of American Art.
Photo: Geoffrey Clements

Lawrence Alloway divided its development into three distinct phases. In the first, which he dates from approximately 1951 to 1958, painters used 'objectively popular material that modified the image of man with which they were all concerned'. In the second phase dated, again approximately, 1957 to 1961 the emphasis shifts to the man-made environment. The basic assumption was that our idea of nature had changed because of the bombardment of our senses by the 'signs, colours and lights of the mass-media'. The function of the second phase, that which he called 'Abstract Pop', (the first he named 'Technological', the

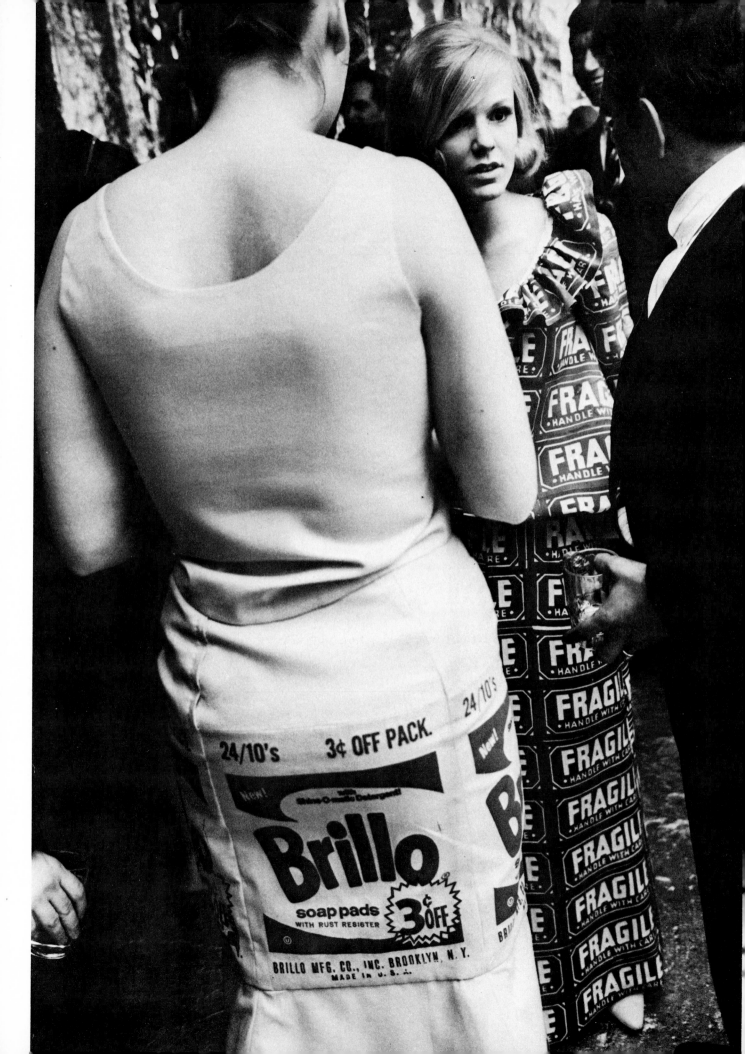

third 'Figurative') was to 'create an analogue of the man-made environment that we all participate in'. From 1961 to 1964, his third phase and that of the second-generation Royal College of Art painters, was distinguished by a return to a figurative expression—the source images employed being overwhelmingly popular.

Certainly there was a cyclical movement according to which images from 'fine' art were exploited by the media and, in turn, the incorporation of vulgar material into art accelerated to such an extent that it is very difficult to discern where the process began.

The symbiotic relationship between fine art and popular culture fascinated artists and commentators alike. Edward Lucie-Smith, in his essay 'Manifestations of Current Social Trends in Contemporary Art' (Jan Creedy (ed.) *The Social Context of Art*), catalogued the feedback process excellently: 'Pop culture makes very wasteful use of ideas, and modern art has turned out to be a fertile source of these . . . modern art has something to give as well as receive . . . once Pop artists had taken advertising images and combined them in a certain way, these combinations and rhythms of arrangement very soon began to find their way back into advertising . . . the whole phenomenon of 'good bad taste', which has become a characteristic part of modern fashion, has its roots in Pop Art.' Richard Hamilton, who with Eduardo Paolozzi and other members of the Independent Group had been perhaps the earliest to develop a pathological interest in popular culture (in the fifties), did not agree with him. In an epic of didactic commitment he wittily articulated the role of the artist in a mass society in a paper, read to a National Union of Teachers Conference, on 'Popular

4. New York society ladies in 'Brillo' and 'Fragile' dresses. Photo: Ken Heyman

5. Eduardo Paolozzi (born 1924): *Towards a New Laocöon.* 1963. Aluminium, 200.7 × 150 × 91.5 cm. (79 × 59 × 36 in.) Artist's collection

13

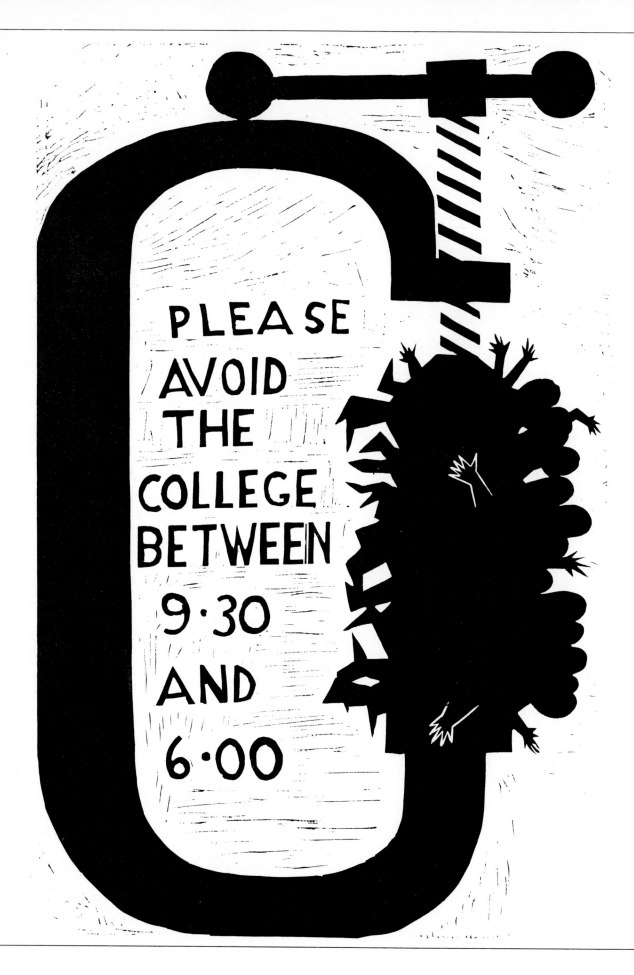

PLEASE
AVOID
THE
COLLEGE
BETWEEN
9·30
AND
6·00

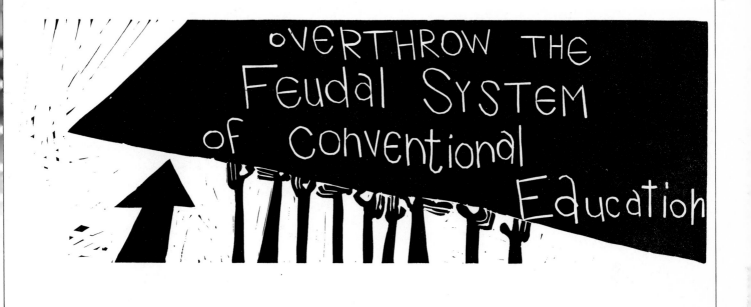

6 and 7. Posters produced by Association of Members of Hornsey College of Art, 1968

Culture and Personal Responsibility' in 1960. Sir Herbert Read was chairman.

It seems to me that the artist, the intellectual, is not the alien that he was, and his consumption of popular culture is due . . . to his new role as a creator of popular culture. Popular art, as distinct from fine art, art created by the people and for the people, does not exist today, its present day equivalent, pop art, is now a consumer product absorbed by the total population, but created for it by the mass-entertainment machine which uses the intellectual as an essential part of its technique.

The results are highly personalized and sophisticated, but also have a healthy vigour.

It is no wonder that commentators like Macdonald were alarmed. Hamilton developed his theme by saying that although the artist participates in the situation, and there was nothing reprehensible in doing so, he should be more aware of the social implications than the normal consumer. 'An ideal culture . . . is one in which each of its numbers accepts the countenance of different values for different

15

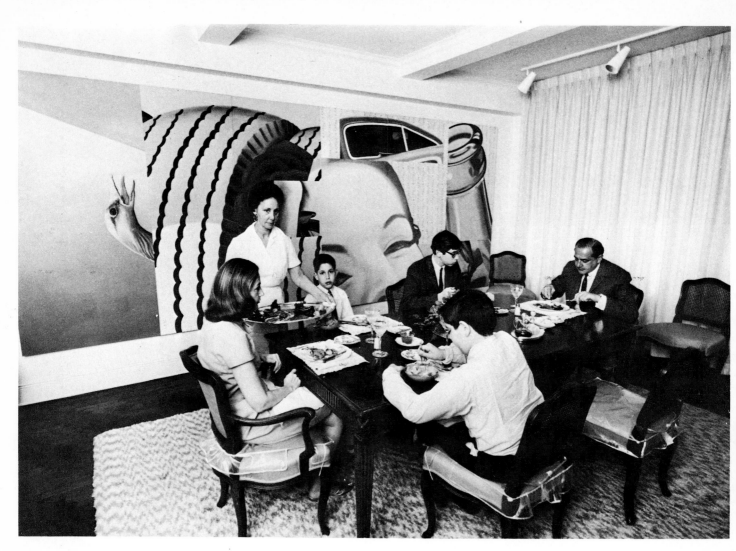

8. Dining room of the Robert C. Scull home. Photo: Ken Heyman

groups and different occasions, one in which the artist holds tight to his own standards for himself and gives the best he can to whom he can without priggishness and with good humour, whilst facing his historic situation with honesty.' William Varley dealt with a different aspect of the rampant stylistic cross-fertilization when he traced the differences between the attitudes and dress of the 'typical' teenager and the art student. Although they shared the same concern with pop fashion, and might look very alike, they differed profoundly, because the art student was an aware 'expert' teenager, and his approach and intention far more serious: 'behind the mod-gear is the iconographer of cultural anthro-pology.' Varley's thesis was reassuring for those who considered the student life-style merely superficial and frivolous: 'how far removed is the sophisticated art student from the typical teenager. His pop-cultural expertise is far greater, his attitude to the media is non-devotional and discriminating; more importantly, what ultimately separates him from the typical teenager is his objective and analytical attitude to contemporary mythology.' He proceeded to distinguish between those having an academic approach to contemporary pop culture and those exploited by it: 'only those who have this analytical attitude seem prepared to use the imagery of contemporary pop culture as the subject

matter of their painting. To those whose attitude to the media is genuinely devotional, contemporary myths, images and heroes are sacred and it would be blasphemy to degrade them by the differing degrees of formal manipulation or distortion necessary in painting.'

Sometimes formal analysis, rather than an intuitive response to, or an anticipation of, contemporary trends took place. The 'Fine Artz' group at the Royal College of Art criticized the contemporary art scene, their approach being essentially constructive. Their treatment in *Ark* (the house magazine of the Royal College of Art) of the teenage netherworld included an analysis of 'the new beat music', 'Kustomizing U.K.' (an interview with Eddy Grimstead who had a scooter customising business in the East End), and 'mod environments'. In their 'A Fine Art View of teenage cults' (*Ark* 36, 1964) the group suggest that a route to the art world's revitalization lay in popular culture: 'the clues of tomorrow's culture lie in the cults of today.' They did however admit that 'since the rate of change in the pop world is constantly accelerating, the majority of details may already be out of date'. Their attitude was refreshingly honest, unashamedly *of* the capitalist society, and highly critical of the traditional introversion of the fine artist. They accepted the fact that the public was familiar with, and expected, constantly changing styles and fashions. They made no judgement on the moral rightness of consumer hedonism: 'ad-men and Wimpy Bar designers don't do badly in supplying the sort of thing that is required nowadays, sometimes even quite imaginatively, but why should they have what amounts to a virtual monopoly in the manipulation of our visual environments?' Their lack of political and social awareness is breathtaking, but political awareness was not fashionable; 1964 was a kind of watershed

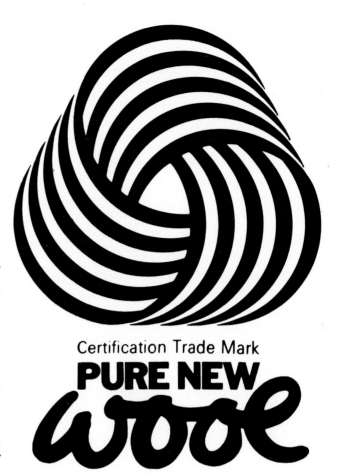

Certification Trade Mark
PURE NEW
wool

9. The Woolmark, designed by Francesco Saroglia, 1964

between the consciousness which motivated Ban the Bomb marches, the beatnik duffel-coated Bohemianism of the late fifties and early sixties, and the later, caftanned flower powerism of Anti-Vietnam war demos. If students were dedicated it was to 'success' and fashion following. Consequently the emphasis was entirely on the façade, on style. The broader vision of two years earlier vanished among the young to reappear when the protest of the later sixties gained momentum.

In 1962 Richard Smith wrote, also in *Ark:* 'The Daz packet is probably designed by someone who regarded "Last year in Marienbad" as entertainment.' He was indicating precisely those myth makers (as Reyner

Banham christened them) whose metaphysical disgust would debar their personal commerce with pop culture, but who cynically exploit those genuinely engaged with it. Looking at Ken Heyman's photographs of the Robert C. Scull home it is obviously a mythmaking family we look at; but it is all too obvious that the Campbells' soup cans and the 7up bottles are for the maid in real-life and sufficiently distanced from the family to permit their use as wall decoration. The question of morality is one that Daz packet designers and cultural anthropologists alike must have dismissed. It is arguable that the Pop artists also, by their celebration of pop-culture, tacitly consented to the exploitation of the less privileged. Pop imagery initially received widespread rejection; it was not, to the *ignoscenti*, proper art: only when refined, and then only eventually, did they accept it. This is why Op

10. Yayoi Kusama (born 1941): *Compulsion-Furniture*. 1966.

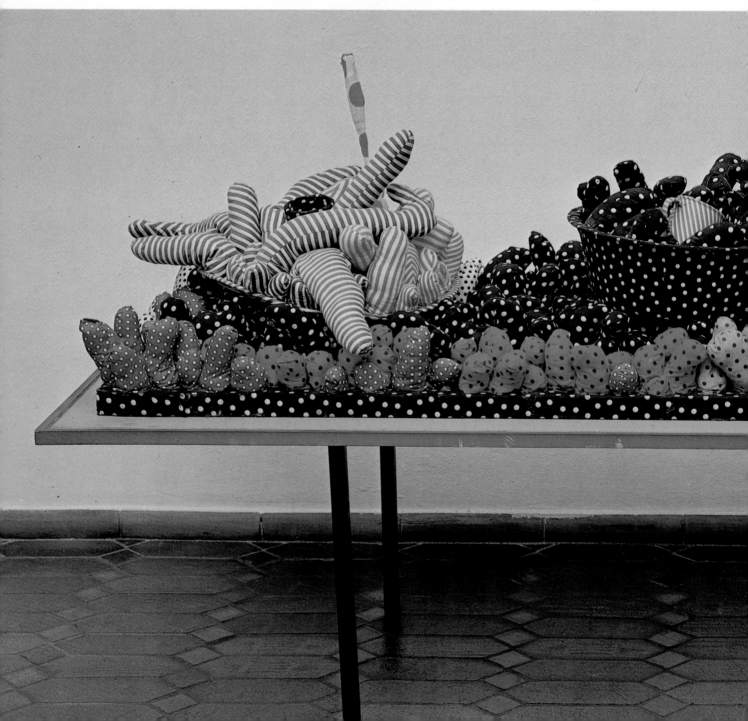

art was immediately successful, and was exploited enormously for advertising purposes early on. Bridget Riley's design for the Woolmark in Piccadilly, Dolcis's shoeshop windows, and the design of sets for television programmes such as 'Top of the Pops' are evidence of this.

Jan Creedy saw Op as 'representing the reassimilation of fine art by the applied arts, the breaking down of a barrier which had its origins in the Renaissance.' I shall deal with this later, but it is naïve to think of Pop, Op, or any other mainstream sixties form as a mid-twentieth century folk art, or as in any way demotic. When Alloway first used the term 'Pop Art' he used it to designate 'Low-Pop', i.e. subjects and objects taken from popular culture. Then what Reyner Banham called 'Fine-Pop' developed: an art making sophisti-cated comments, rather than reflecting any

Objects covered in cloth, 207 × 57 cm. (81½ × 22½ in.) Cologne, Ludwig Museum

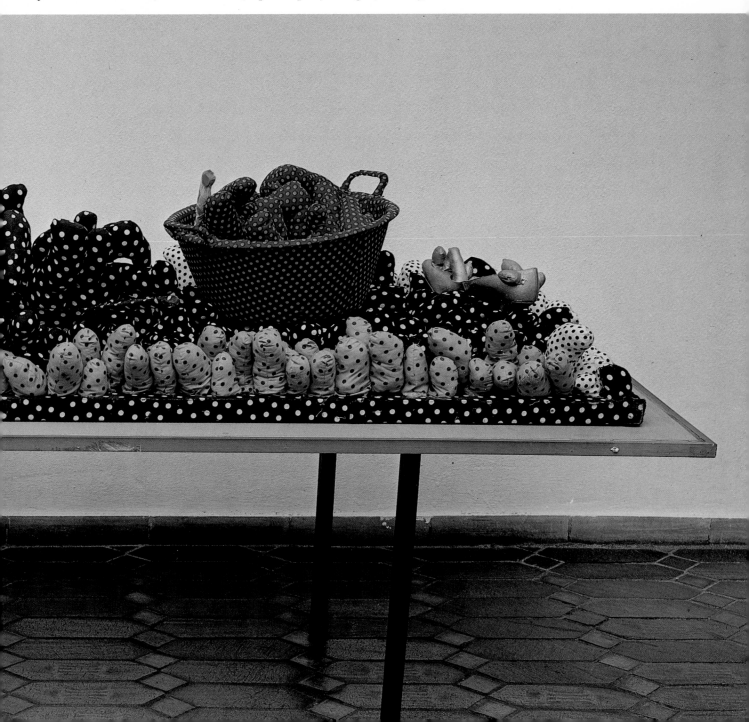

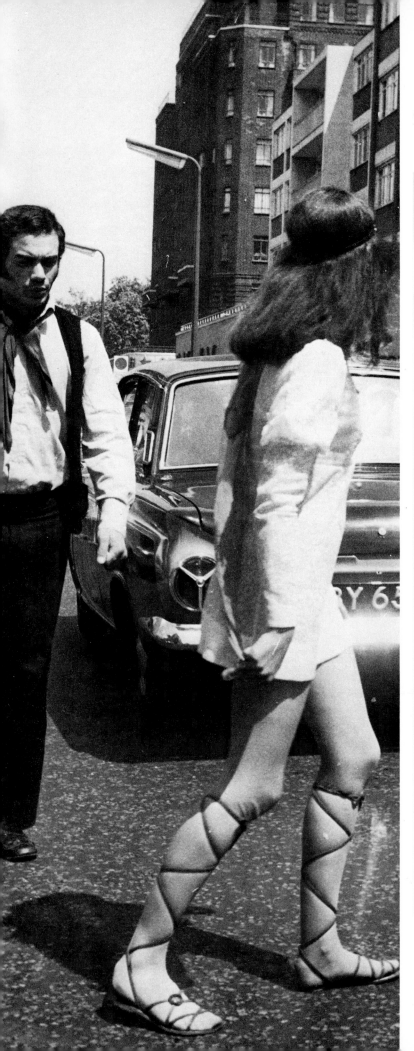

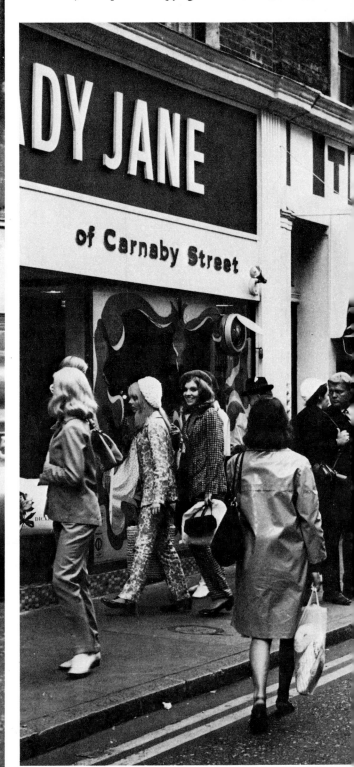

11, 12 and 13. London streets in the sixties: King's Road (photo: Anthony Fisher); Carnaby Street (photo: Ivor Watkins); the Beatles' boutique 'Apple' (photo: Peter Mitchell). All photos copyright Camera Press Ltd.

democratic ideal. This might indeed have made its start in the 'aesthetic of the vulgar and common-place', and sought 'those terrible beauties concealed in the vulgar and banal, but it was certainly not an art made by the people and for the people. The cyclical or symbiotic process that was completed when the media took up 'Fine-Pop', and made it high fashion through such exposure, was merely the digestion, and regurgitation in refined form, of what they had unwittingly started.

Painting and sculpture often degenerated into being encomiums of popular culture *per se* and art often became no more than a simple transposition of banal everyday objects into unwonted situations, so that by 1962 Alloway had extended his earlier definition of Pop to embrace all artists who dealt with popular images in a fine art context.

The concept of a 'self-contained' art work raises the question of the degree to which the incorporation of popular materials into art really constitutes a closer relationship between the art of the few and the real-life activities of the many. In fact the incorporation of vulgar materials into art is a strong twentieth-century tradition. The Combines, Assemblages, Environments and Happenings of the late fifties and early sixties were manifestations of the same 'collage' principle, and imparted a freshness and life into the pallid and hermetic art world.

A number of artists during the sixties began working toward evolving structures and practices which enabled them to explore the 'gap between art and life' as expressed by Rauschenberg in his essay 'The Bride and the Batchelors'. They enjoyed limited success; but it is true to say that the sixties were a period of general creativity. People developed idio-syncratic domestic environments, clothes etc., with an exuberant awareness of the possibility of 'found' materials and a lack of self-

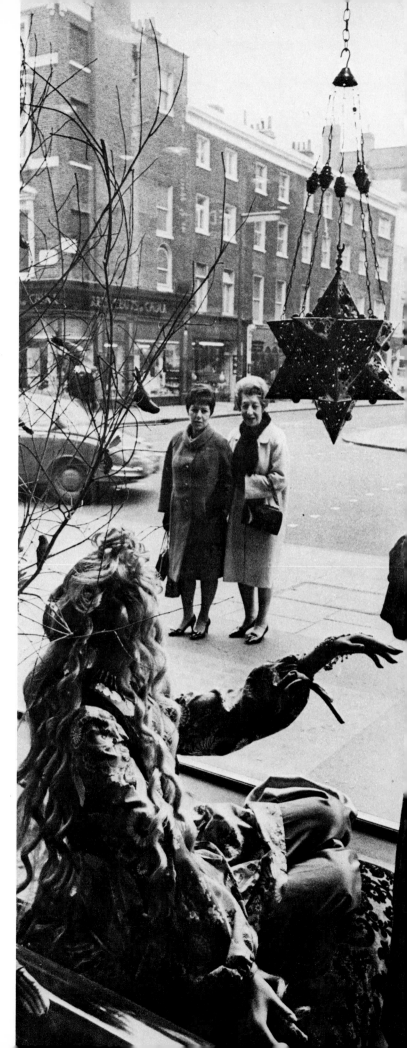

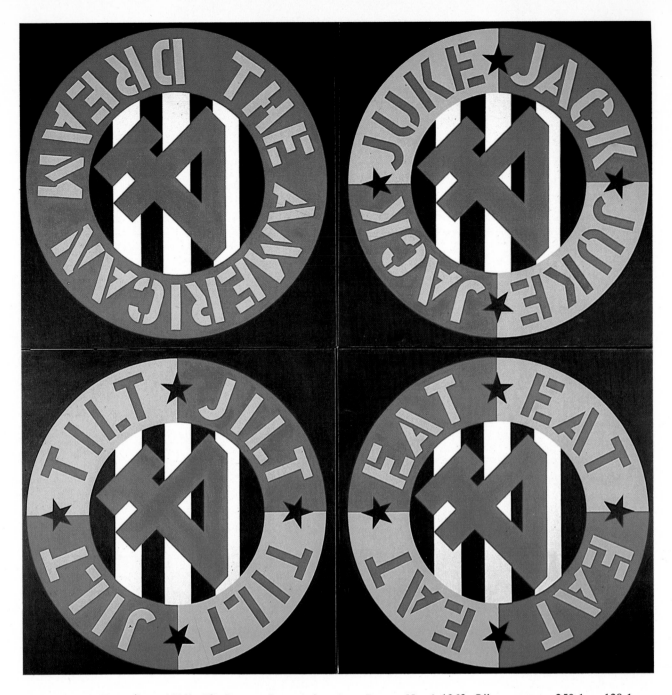

14. Robert Indiana (born 1928): *The Beware-Danger American Dream No. 4*. 1963. Oil on canvas, 259.1 × 198.1 cm. (102 × 78 in.) Washington, Hirshhorn Museum, Smithsonian Institution. Photo: John Tennant

consciousness. Capitalism rapidly moved in, creating markets in pseudo-antiques and what may fairly be called 'chi-chi junk'. The resultant diffusion of pop imagery throughout society (reflected in derivatives of Carnaby Street boutiques flowering in the most unlikely provincial towns) led to optimism on the part of educationalists that the situation could be

exploited for teaching purposes. This feeling was expressed by Richard Hamilton at the 1960 NUT Conference on Popular Culture and Personal Responsibility: 'The fine artist, the

15. Karl Wirsum (born 1939): *Screamin J Hawkins*. 1968. Acrylic, 121.9 × 91.4 cm. (48 × 36 in.) Chicago, The Art Institute

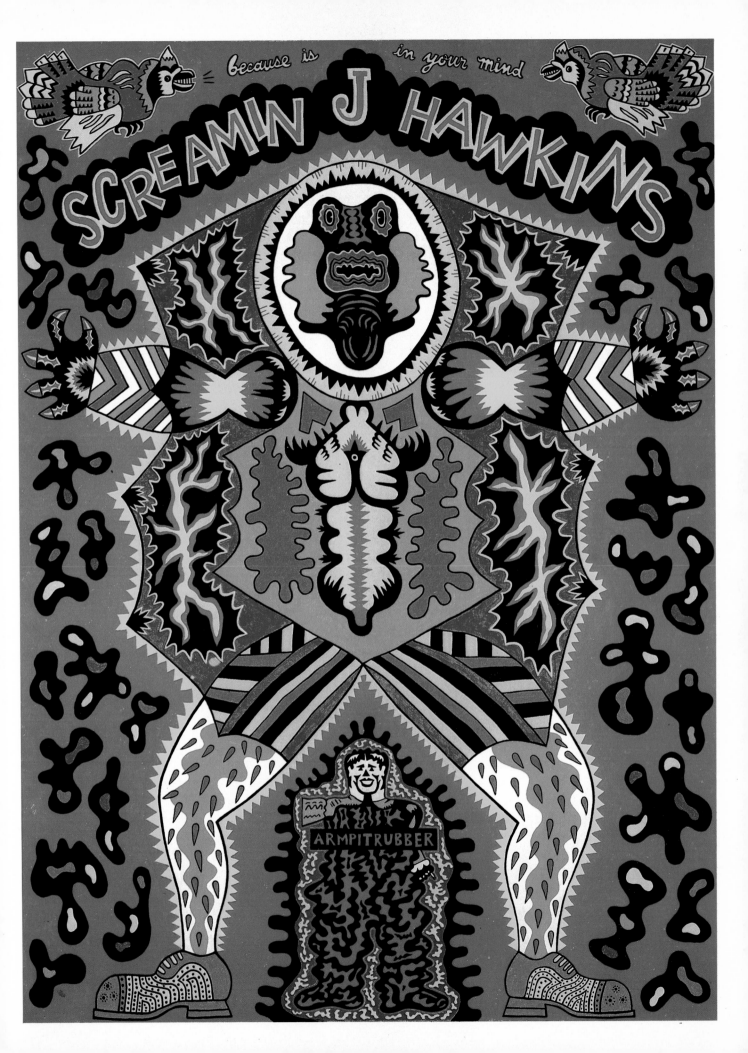

intellectual, can and should work within the dual terms of the title of this conference. When contributing to popular culture through the mass-media he must feel a sense of personal responsibility as part of that culture and recognize that his art is directed towards an audience and their needs.' Substantially the optimism was misplaced and there was nothing but a vast growth of academic courses in 'media' and 'communication' studies, which merely examined, rather than exploited Pop in the educational process.

The acceleration and increase in stylistic cross-fertilization, coincident with the emergence of the 'electronic global village', meant the easier transition of national boundaries, and the emergence of a latter-day 'international style' of visual communication. Greater affluence meant more public entertainment: the number of prestigious international exhibitions increased. It is perhaps possible to over-emphasize the degree of influence America had on Britain, but it would be impossible to do the reverse. The influence was primarily a cultural one. Painting and sculpture retained, for the most part, their national characteristics (though the influence of Americans on British intermedia activities was great.) Between 1959 and 1970 there were seventy one-man shows of American artists in Britain, and twenty-four group exhibitions. During the same period there was an even greater representation of British artists in the United States.

During such a period of frenetic activity labelling became a major disease. Unlike in the past, when labelling was generally posthumous, there was a plethora of over-zealous labelling (mentioned by Wolfe, among others), not only on the part of the critics, but also the popular press: Neo Dada, New Realism, Op, Pop, Kinetic, Tachism, Hard-Edge, Colour Field, Minimalist, Aleatory, Conceptual, Event, Earth were among those

that were used within quite a short period. Both groups became assiduous in detecting new trends, which seems to relate more to the convenience of the market place than the academy. This drive to recognize and consecrate the newest thing has meant that time has tarnished, even more rapidly than it is wont, the reputation of much work which received contemporary acclaim, but it has also meant the recent rehabilitation of disregarded activities, so that we recognize the precursors of latter-day 'alternative developments'. As it is probably true to say that the 1960s were the last decade in which painting held sway, representing the last flicker of hope for those collectors who thought that art might have a decorative purpose, the importance of this should not be underestimated.

Towards the end of the sixties increasing numbers of artists began not only rejecting painting, but repudiating any tangible object that might be a pawn in a process of profit making and commodity exchange. Although those taking this stance gained ground enormously, they did not succeed in consolidating it during the period. Critics on the whole backed the development of hybrid forms, though a number of influential voices protested. The uniqueness of sixties art, Bannard claimed, was that bad art was new and important. The co-existence of a multiplicity of styles he thought a peculiarly sixties phenomenon and dismissed hybrid forms, and alternative media alike, as 'novelty art': 'The fear of being "wrong" fosters bad art as long as the art public is not sure that it is actually bad. History has told them to go along with whatever seems to persist.' Although the argument is compelling, it is

16. James Rosenquist (born 1933): *Early in the Morning*. 1963. Oil on canvas with plastic, 241.3 × 142.2 cm. (95 × 56 in.) Collection of Sydney and Frances Lewis

24

not difficult to resist his conclusion, particularly as he objected to all hybrid forms at a time when even conventional idioms could be found wanting in respect of resistance to pure novelty. One feels that in stimulating a conservative-formalist argument he should have restricted his examples to painting and sculpture alone, for he was objecting to only a modest extension to conventional expression in both. However, in order to bolster his argument, he extended his examples to include the hybrid and the ephemeral, when his quarrel

17. Duane Hanson (b. 1925): *Bowery Bums*. 1969-70. Fibreglass, polyester, found materials. Aachen, Ludwig Coll.

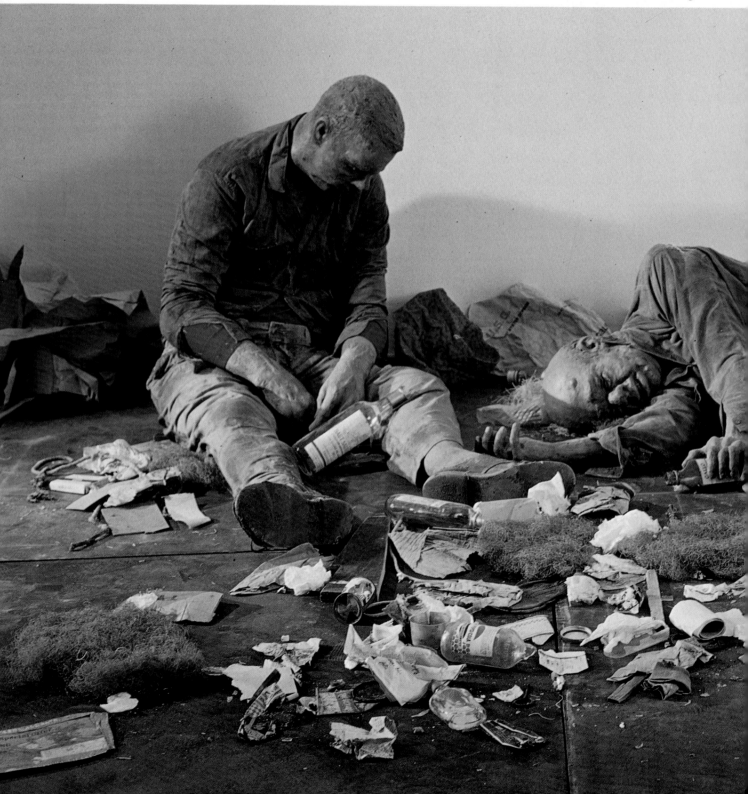

was really over more restricted categories.

No one could be more critical of those than Allan Kaprow, the high-priest of one alternative mode: 'Although there is good work being done in the conventionalist arts—painting, sculpture, music, dance, poetry, etc., the newest energies are gathering in the crossovers, the areas of impurity, the blurs which remain after the usual boundaries have been eased. This zone is increasingly referred to as 'intermedia' (Dick Higgin's term for media between media) and within this zone I see the most critical point of oscillation occurring between intermedia and life.'

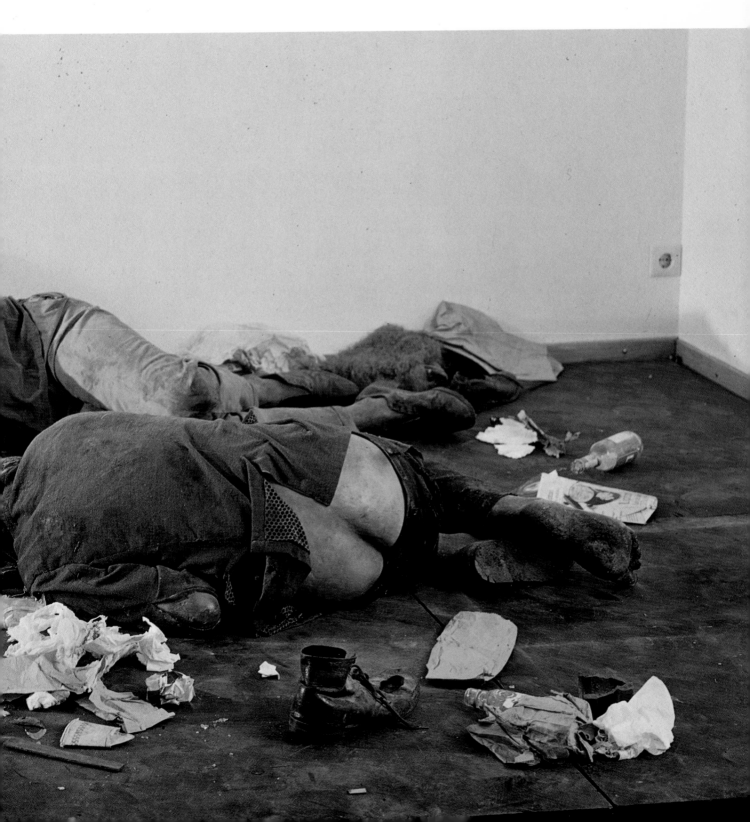

In this area most of what is vigorous and interesting in sixties art lies, but what occurred has been substantially buried because it aroused little media interest. It was neither attractive, nor attractively packaged, and was little written about because the commercial gallery system found no way of making any money out of it. If we examine Kaprow's statement closely we detect an air of defensiveness. In admitting that there was much of interest in conventionalist activities, he has the definite air of 'kicking against the pricks'. Six years later Victor Burgin does the same, although being British he had a greater threshold of intolerance to kick against. In what is almost a paraphrase of Kaprow he states, 'If a thing appears which is neither one thing nor another within an established classification, it should not therefore be suppressed as it may be the seed from which an alternative and instructive classification may be grown.' Yet suppressed these things effectively were. Apart from the exploitation of the Destruction in Art Symposium as scandal fodder, John Latham's symbolic ingestion of the St Martin's School of Art library copy of Greenburg's 'Art and Culture', significant 'alternative' cultural events, got no serious treatment, except in a small number of specialist art journals. Even the *Guardian*—generally so liberal and so thoughtful, snootily dismissed the *Destruction in Art Symposium* events (despite seeming momentarily impressed that it had attracted participants from ten countries): 'But pictures of women bundled up in transparent sacks, or of men smeared with blood and muck, whatever the artistic purpose, are more likely to degrade than to exalt. Violence makes violence . . . destruction in art is mainly perverse, ugly, and antisocial'. One result is that the most mundane of happenings have acquired an air of myth-laden exoticism as a result of the machinations of the popular press. The latter managed to throw up its hands in horror and at the same time achieve a *frisson* of delight at the thought of the wonderful copy it was all providing.

In 1967 Irving Sandler and Barbara Rose constructed a questionnaire in order to determine what precisely the 'Sensibility of the Sixties' was. In it they attempted to elicit the differing attitudes of artists of the New York School and their successors who gained prominence in the sixties. Not only was there a feeling among the former that commercialism had replaced the true spirit of the avant-garde, but they felt that the acceptance of art by the general public was superficial. Despite the fact that Norbert Lynton, in his review of the BBC television programme 'Pop Goes The Easel' (1962), wrote that he could think of no other occasion when British TV had greeted new art with comparable interest and affection, one feels that this reflects an attitude of producers and programme planners rather than a genuine understanding on the part of the public. Most of what was seen on television and in non-specialist magazines was the trivial treatment of often shallow work. Undeniably there was a greater consumption of material relating to art (of the less ephemeral journals *Art and Artists*, *Studio International*, *Art Forum* and *Arts Review* all made their first appearance, or underwent significant metamorphoses, during the period). Many felt that if the artist had honestly faced his true situation in society, and had stated his position with clarity, he would have had more success in paving the route to an integration of art with society at large: 'the artist may have to begin thinking in modern, i.e. corporate, terms. He may have to explore not only the nature of technological processes, but the effect these have on human life . . .

18. Bandaged Vietnamese Female. 1967. Photo: Philip Jones Griffiths. Courtesy of Magnum Photos

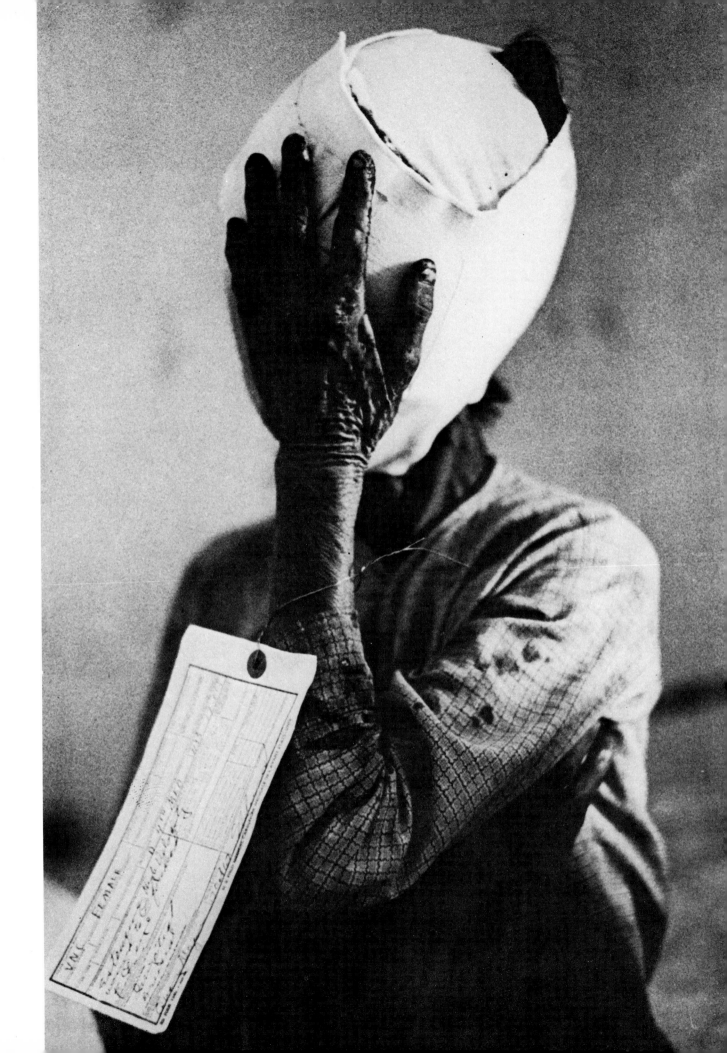

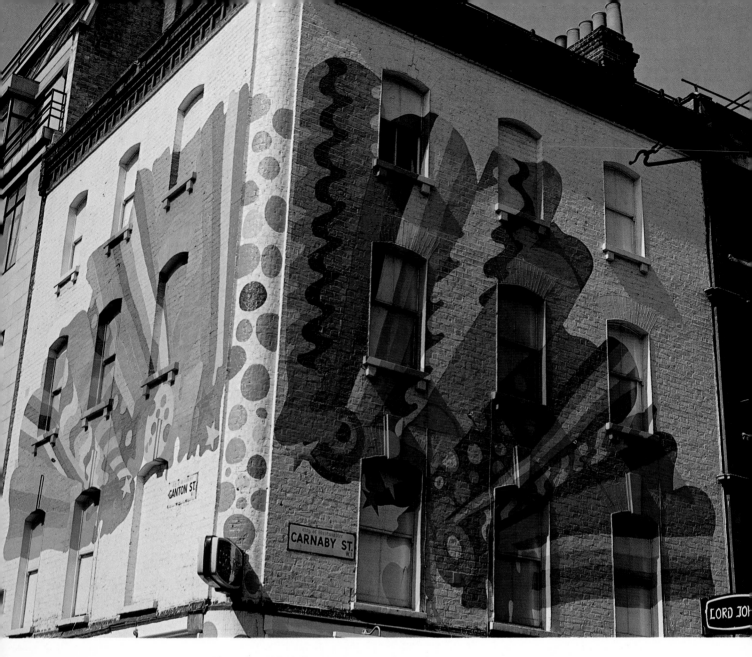

19. Painted building in Carnaby Street, London (photo: Gerald Clyde)

Diversification and efficient distribution—characteristics of a successful economy—would become operations leading to freedom, rather than to the stigma of commercialisation and sell-out.' Although it *sounds* like Fine Artz the statement is Kaprow's. As usual the position of the artist was equivocal: success etc., on the one hand, and the call of social conscience on the other. Happily mid-twentieth century technology provided a partial salve to the latter: 'original' artworks for the rich, limited edition multiples and prints for the tasteful middle-classes, and posters for students. The *hoi-polloi* stuck to their reproductions of *The Hay Wain* and Tretchikoff's *The Chinese Girl*. André Malraux's theory, that it is the degree of

20. James Rosenquist (born 1933): *Marilyn Monroe I.* 1962. Oil and spray enamel on canvas, 236.2 × 190.5 cm. (93 × 75 in.) New York, The Museum of Modern Art; the Sydney and Harriet Janis Collection

30

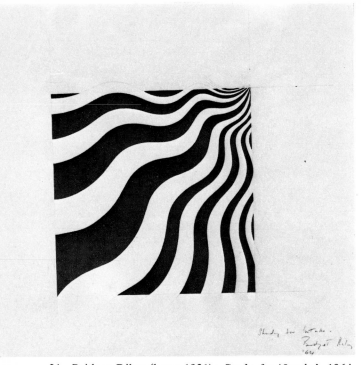

21. Bridget Riley (born 1931): *Study for 'Intake'*. 1964.
Ink and pencil on paper, 76.2 × 56.2 cm. (30 × 22¼ in.)
London, Rowan Gallery. Photo: John Webb

dissemination that an image receives which determines its status and place in art history, if we accept it, dictates that this painting, or one of its porno-kitsch kindred, will have a higher status than the *Mona Lisa*.

The recognized function of art remained what it had always been and no significant inroads were made into developing an alternative. The 'new found' public for art was no more capable than its predecessors of distinguishing between the worth of emporium objects and gallery objects. Without significant development in the education process how could it be otherwise? In the absence of the latter an understanding of 'serious art'—that which makes intellectual demands—was impossible. Do we assume then that the new art was undemanding because people went in greatly increased numbers to see it?

The truth lies somewhere between the two possibilities. The mass of the public did not actually go to the Tate and the Whitechapel to look at art any more than nineteenth-century socialites went to see the opera. They went because it was a fashionable place to go or because the ambience was pleasant.

It was during this period that the gallery as an environment took primacy over what was displayed. Even if the artist's *œuvre* was inaccessible, the ballyhoo and personality-cult promotion of the artist obscured the fact. The gallery and the emporium were equated by the media, in their colour supplement treatment of art as high fashion, and the public, in almost a decade-long burst of affluent hedonism, consumed. The leeches on the artist's back multiplied: in the world of 'You've never had it so good' galleries proliferated, art institutions expanded, and the media presentation of the artist as pop-idol rescued him from his lonely attic. If his new role was a little undefined, it was still better to be down from the cold. If his objects and images became part of the big sell, that was OK too . . . and that's what happened. Roaring young lions of the early sixties became sleek purring, sedentary ones later, their art consequently soft, and sufficiently accessible for the manipulators and middle-men to be able to package producer and bland product alike. Mainstream art of the sixties: Pop, Post-Pop, Minimalist, Op, Shaped Canvas, Colour-Field, and all the others can be seen as having indulged in a giddy ten-year dance, often very colourful, often quite sensual; sometimes heady, sometimes tasteful. Predominantly it was self-indulgent, a dance behind thick glass, sealed in from the great forces moving and affecting society. It was a *danse macabre*. The whole epoch has an air of Mardi-Gras, and Lent followed. 'The war' no longer was worlds away; the money ran out, the consciences got a little active. Events in the streets of New York, San Francisco, Paris, even London, became more interesting and compelling and

32

art, even alternative, unless it was politically exploitable, became an irrelevance.

In the summer of 1977 the Royal Academy mounted a major exhibition *British Paintings 1952-77*. Despite the fact that the work shown was the cream of two generations, the overwhelming impression one got was of staleness. Richard Cork saw the show as a gesture and felt that the Royal Academicians were using it to heal the breach between themselves and modernist painters because both groups were feeling increasingly beleaguered in the face of developments in other forms of visual expression. He felt it emphasized the preparedness of contemporary artists to reiterate (in a spirit of almost abject reverence) the achievements of American painters during the 1950s and early 1960s. He demolished the notion that their presentation of a common front would have any effect: 'But let none of these artists imagine that painting is thereby poised to resume a central position in our culture again. For more drastic and radical steps will have to be taken before that pipe dream becomes a reality.' Peter Fuller, in 'The Crisis in British Art' (*Artforum*), said that leading painters and sculptors of the sixties were overestimated, giving as examples Hamilton, Riley and Caro to demonstrate that they had 'failed to transcend the prevalent illusions of the late 1950s and early 1960s, the ideology of the Affluent Society.' Aesthetic claims he thought overstated, though the 'relative vitality is indisputable', despite what he felt was the works' ephemeral and shallow nature. His argument is that British visual arts had become sterile, 'lacking creative oppositions, with no audience other than the contracting "art world" itself'. This cry of woe has distinct echoes of an earlier, equally histrionic, catalogue of despair, *The Painted World*, Tom Wolfe's send up of the American sixties scene. After a brilliant comparison of the art community's huddling together for

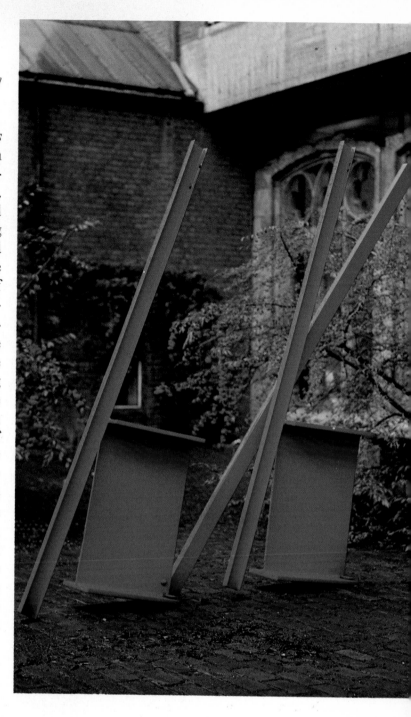

22. Anthony Caro (born 1924): *Prospect II*. 1964. Iron, oil, 260 × 215 × 31 cm. (102¼ × 84¾ × 12¼ in.) Cologne, Ludwig Museum

warmth with oecumenicism in the church, Fuller uses Lewis Carroll to make his point for him:

> But the valley grew narrower still
> And the evening grew darker and colder,
> Till (merely from nervousness, not from
> goodwill)
> They marched along shoulder to shoulder.

The contrast with the mindless optimism of the mid-sixties is remarkable; the lack of self-confidence that became general among the art community in the mid-seventies might, far more appropriately, have taken place ten years earlier.

In what was both an encomium of purist forms and an attack on minimalist, inter-media and 'democratic' art, all of which he saw as being a debasement in taste, Ad Reinhardt spoke what was almost the epitaph for formalist values. Ironically, the great advance of hybrid forms occurred after his death in 1967. At the beginning of the period Reinhardt was virulently critical of what were to become its dominant characteristics. He was almost alone in his wider moral concerns (expressed in his Address to the College Art Association Jan. 1960): 'what is the "Failure of Art-Conscience" at present? . . . what are the unconscionable crimes of artists? . . . Is the art "sink of corruption" like any other sink? . . . art is not.'

'Corruption in art cycles moves forward always in the name of life, fate, nature, humanity, animality, society, cosmic-anxiety, reality, surreality . . etc. The reform move-ment and atonement occurs always as a return to the strong neo-classic virtues of detachment, honesty, rationality, clarity, coldness, empti-ness, sterility, formalism, intellectuality, idealism, meaninglessness and contentless-ness.' Reinhardt was against the fashionability of the sixties. His major shortcomings were a supposition that he held a corner in moral righteousness, and lack of humour in failing to turn the 'corruption' of his generation to good advantage. In a similar situation Edward Kienholtz succeeded: he recognized the same symptoms of sickness in art as Reinhardt, but diagnosed a different *malaise*. Kienholtz, one of the gutsier artists of the period, in a vigorous appraisal of what was reprehensible in American society, demonstrated its short-comings with acerbic humour in his 'conceptual tableau' of 1963. He mimicked art-world conventions such as the opening preview and the limited edition; the preciousness of art-documentation, and the self-conscious, cash-conscious trendiness of the whole scene. His work was a typed statement defining the ethos of the gallery/preview/crowd with the gallery itself as the art work 'documented'. He identified and displayed various taste continua, and behavioural peculiarities of certain cities. He developed a conceptual 'set': invented work, invented style, invented artist. Sale prices were also invented: $15,000 for the set itself, another $1,000 for the set animated by the art crowd, and a sum to be determined for the sound recording of the opening and 'a dessi-cated punch bowl.'

In 1968, John Baldessari employed a similar scheme, taking a swipe at the preciousness of both contemporary art and criticism. In a series of works he employed a signwriter to put various texts on plain grounds, among them, *Everything is purged from this painting but art. No ideas have entered this work. A painting that is its own documentation.* The results are at first totally ambiguous but the message is clear when we place them in context. The fact that he literally spelled out messages such as 'This painting owes its existence to prior paintings . . . you should not be blocked in your acceptance of prior inventions . . . to like this painting you will have to understand prior work, etc.' is a repudiation of traditional modes. It is no

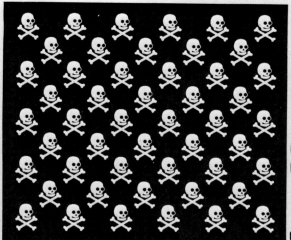

U.S.A. SURPASSES ALL THE GENOCIDE RECORDS!

KUBLAI KHAN MASSACRES 10% IN NEAR EAST

SPAIN MASSACRES 10% OF AMERICAN INDIANS

JOSEPH STALIN MASSACRES 5% OF RUSSIANS

NAZIS MASSACRE 5% OF OCCUPIED EUROPEANS AND 75% OF EUROPEAN JEWS

U.S.A. MASSACRES 6.5% OF SOUTH VIETNAMESE & 75% OF AMERICAN INDIANS

FOR CALCULATIONS & REFERENCES WRITE TO: P.O.BOX 180, NEW YORK, N.Y. 10013

23. George Maciunas: *U.S.A. Surpasses All Genocide Records.* 1969. Poster. Artist's collection

coincidence that a number of influential publications also carried the message that galleries and painting were finished.

The demise of painting, at least as dominant medium, was marked by a general and unprecedented adulation of the artist, as well as being witnessed by a larger art audience than ever before. During the sixties he emerged as media darling. If the fashion model and the artist were not strange bedfellows, it was the first time they were photographed together for down-market pop-magazines. Wolfe's portrayal of the New York art scene has been well complemented by Lynda Morris's treatment of the British one in her awkward, but well researched, article 'What is it that made the sixties art so successful, so shallow?' The lionization of the artist was a corollary of the process whereby the art-object became a consumer product, no less subject to fashion whims than any other (new season — new product), so that the need for novelty became the prime condition for much of sixties art. A consequence was that the character and image of the artist also needed re-styling from time to time. As it was impossible for this to happen to a great extent, the only alternatives were for him to die young, turn himself into the art object like Hockney and Warhol (so that his doings and opinions took precedence over any work he might produce), or to fade away and hope for resurrection later. As almost the whole art system embraced planned obsolescence the artist had little choice but to come up with new ideas each season or vanish. This view received surprising confirmation

35

from Allan Kaprow: 'Participation in and even initiating many movements would then become almost a formula for continuous self-renewal. Diversification and efficient distribution—characteristics of a successful economy—would then become operations leading to freedom, rather than commercialism and sell-out.' This optimistic affirmation of the values of capitalism and pluralism was Kaprow's route to redemption and the avoidance of premature death. It was not to change the practice, but to present a different public image, so as to avoid the stigma of commercialism, 'in order to beat the game of dying for a brief hour of life in art the artist may have to begin thinking in modern, i.e. in corporate terms.'

Both Tom Wolfe and Lynda Morris have given disturbing accounts of the machinations of the art establishment and of the emergence, like thoroughbred stallions, of certain carefully marketed artists. An even superficial examination of contemporary documents and of the relationship between dealers, artists, patrons, and committee sitters illustrates the truth of both theses.

In the early sixties one of the main arenas in which artists could compete for the attention of the West End (commercial) galleries, and for fame and fortune, was the 'Young Contemporaries' exhibition. This, organized by students themselves, with their choice of jury, lifted the 'second generation' of British Pop painters into the limelight. I remember well the *frisson* of excitement running through the art school studios (just beginning to smell of acrylics and fibre glass) when the successful aspirants were known: 'Tomorrow the world!' Not so unfamiliar is Wolfe's description in *The Painted Word* of Alfred Barr and Dorothy Miller of the Museum of Modern Art, New York, on their annual spring talent-spotting expedition. They toured studios of artists known and unknown, in order to determine what was new and significant so that they might get an autumn show together: ' . . . and, well, I mean my God—from the moment the two of them stepped out on Fifty-Third Street to grab a cab, some sort of *boho* (bohemian) radar began to record their sortie . . . *They're coming* . . . And rolling across Lower Manhattan, like the Cosmic Pulse of the theosophists, would be a unitary heartbeat: 'Pick me pick me pick me pick me pick me pick me pick me . . . O damnable Uptown'. Wolfe heavy-handedly catalogues the 'integration' of the artist with upper middle class, Upper East Side society and the retention, as he puts it, of his artistic integrity—his virginity, by his retention of paint-stained jeans with a dinner jacket at M.O.M.A. 'black tie' openings.

Morris cites similar British examples, but what exemplifies the social milieu of British artists perfectly is Richard Hamilton's print *Swingeing London '67*. In the print (adapted from a newspaper source image) Robert Fraser, gallery owner, and Hamilton's dealer, is shown handcuffed to Mick Jagger of the Rolling Stones after their arrest on drugs charges. It was Fraser who said that his best customers were the Beatles and the Rolling Stones. Artists in Britain and America who achieved any fame were in there with the pop-stars and fashion designers rather than with more conventional myth-makers. This curious cultural community 'breathlessly *à la mode*' was described by Dr Jonathan Miller in *Queen* magazine as 'where Lord Snowdon and other desperadoes of the grainy blow-up, jostle with art students, Mersey stars, window-dressers and Carnaby Street pants peddlers'.

The search for fame, money and beautiful lovers, which are, according to Freud, the ambitions of the artist, was not confined to pop-painters, it is a quest that most twentieth-century artists have shared, but it became more pronounced during the sixties. It is not difficult to discern why. The whole educational

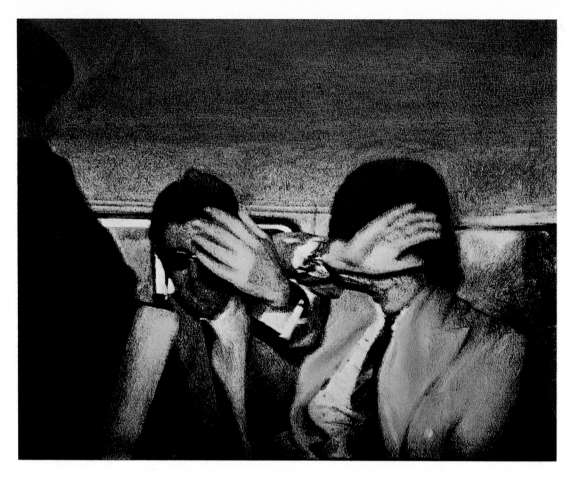

24. Richard Hamilton (born 1922): *Swingeing London 67 II*.
Screenprint, oil on canvas, 67 × 85 cm. (26¾ × 33½ in.) Cologne, Ludwig Museum

25. Richard Hamilton (born 1922): *Swingeing London 1967*. 1968-9. Acrylic on metal and canvas,
67.3 × 85.1 cm. (26½ × 33½ in.) Courtesy of The Arts Council. Photo: John Webb

system is based on the capitalist premise, and art students receive a thorough conditioning process that leads them to suppose that 'success' lies in appealing to a small côterie rather than communicating seriously and well with the crowd. It might be argued that they did do precisely this in the sixties, but it was not so. Any compelling ideas were so filtered by exploitative structures that they were diluted and debased. Either the work was as hieratic and hermetic as it had always been, or it was reduced to mindless pop image peddlings. A proper level for the exchange of serious ideas to the larger audience was never arrived at. Yet there were positive gains. The audience, although merely demanding novelty and sensation, put pressure on museums and galleries to be more than passive mausolea, repositories of 'finished' culture. They were required to respond to the consumers' needs in the way that the artists were. It was from this date that educational and interpretive services began to be built up. They also increasingly became venues in which an art process took place as described by Edward Lucie-Smith, 'A museum, was originally a repository; its job was to conserve art as much as to display it: today a museum of modern art is something more closely resembling a theatre, where the drama of modern art is played out before an audience. It is something dynamic rather than static.'

It is ironic that many of the most effective catalysts in sixties art were museum based. Henry Geldzahler at the Metropolitan Museum of Art in New York wielded enormous influence despite the fact that he enjoyed no budget for purchases. Alan Solomon at the Jewish Museum was another such figure. The Whitney, the Guggenheim and M.O.M.A., more deliberately, became *venues* for contemporary art:

> The orientation of the museum is no longer towards the past . . . the museum today and those who direct it are turned to the future, toward new trends—if these are not present the museum endeavours to create them. Its representatives circle around the globe in the hope, not of excavating art history but of *making* art history. They seek a role in the historical drama similar to that of artists . . . since it is they who determine what art is.
>
> (Harold Rosenberg in *Artworks and Packages*)

Thus an élite of the shapers and manipulators of art was extended.

The dominance of this intermediate group between artist and consumer in Britain is both remarkable and dismaying. If gallery owners parcelled out carefully controlled doses of their commodities then they were ably aided, if unconsciously, by a hideous pair of twins: the British Council and the Arts Council of Great Britain. The former disseminates British cultural products abroad, the latter does roughly the same for internal consumption. Both tend to be staffed by people from fairly privileged backgrounds, which divorces them effectively from the mass of people. Successfully, by interventionist and paternalistic patronage, they obtained a stranglehold on the arts, consolidating it substantially during the sixties. They have confidently imposed the diluted 'county' taste continuum of their social class for two generations. Modifying their policies slightly because of the need to appear liberal and tolerant, they reinforced those tendencies inherent in British art at just that time when viable alternatives were beginning to emerge. This taste, and its proselytes, have become very powerful. The reason for this is that, as a result of the movement away from the art object, due to its perceived status as an item of commodity exchange, the Arts Council has emerged with an apparent corner in righteousness. The misconception that it somehow commissions, buys, and displays art in a 'neutral' way for the public good, has gained it a false moral edge, allowing those artists, for whom the

26. George Segal (born 1924): *Legend of Lot*. 1966.
Mixed media, 182.9 × 243.8 × 274.3 cm. (72 × 96 × 108 in.) New York, Sidney Janis Gallery

commercial system is repugnant, to become ensnared by it. The situation is dismaying, because it developed largely unrecognized, creating the illusion of a healthy free art, when there was no such thing but a form of subtle self-censorship resulting in a soft-core British aesthetic.

Other institutions concerned with the display of contemporary art were equally fettered. The Tate Gallery, the Whitechapel Art Gallery, and the Institute of Contemporary Arts, to name three of the most influential sixties *venues*, each had good capitalists as their trustees. Art institutions in the sixties, private and public alike, were inextricably wedded to capital. However altruistic individuals might have been, head-on confrontation with the host-system had to be avoided if funding was not to suffer. Lynda Morris hardly began to unravel the ramifi-

27. Richard Smith (born 1931): *Panatella*. 1961.
Oil on canvas, 228.6 × 304.8 cm. (90 × 120 in.) London, Tate Gallery

cations of these relationships in her articles, but nevertheless gave sufficient reason to doubt that they operated in the interests of completely free expression. Similarly she queried the influence that a few commercial galleries might have on the constitution of public collections and on what was included in foreign shows. As in the case of Britain's contribution to the Venice Biennale of 1966: 'the British pavilion contained the work of Harold Cohen, Bernard Cohen, Robin Denny, Dick Smith and Anthony Caro. At the time cynics were calling it "Kasmin's Biennale".'

It would be pleasant to think that the situation differed in other countries, but it did not. A handful of commerical galleries in the States—Leo Castelli, Sonnabend, and Sidney Janis in New York—exerted as much of a grip as Fraser and Kasmin in London. Because of the vagaries of British public patronage, artists were considerably more limited when it came to developing alternative systems of display. Paradoxically, British institutions, founded largely as a result of socialist post-war initiatives, acted as bastions for the capitalist *status quo*, while in the United States, govern-

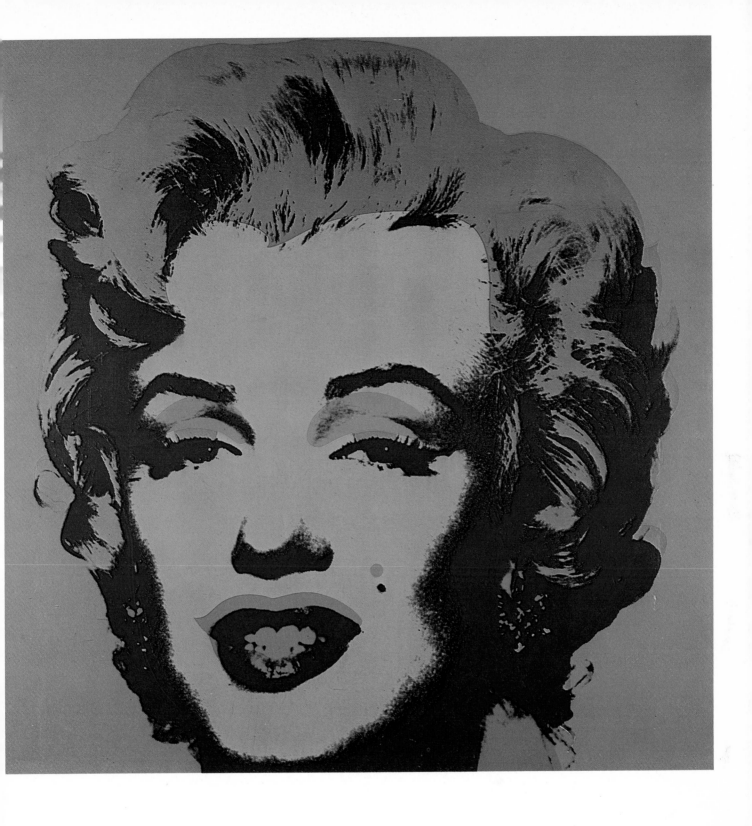

28. Andy Warhol (born 1930): *Marilyn Monroe*. 1967.
Silk-screen print, 92 × 92 cm. (36¼ × 36¼ in.) Cologne, Ludwig Museum

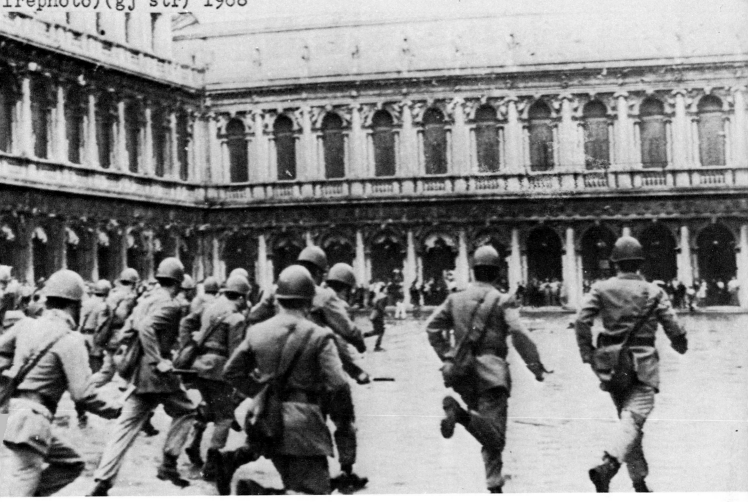

ROM 2) Venice,Italy,June 20(AP)Club-swinging police charging into
he crowd of demonstrators sheltered under the arcades of St.Mark's
quare in the second day of violence over the opening of the Bien-
ale Art Exhibit.The students were protesting the opening of the
iennale,one of the world's largest contemporary art exhibit.(AP
irephoto)(gj str) 1968

30. Police charge at the Venice Biennale, 20 June 1968. Courtesy of Associated Press

ment and quasi-governmental agencies were restricted to a lower level of intervention and were correctly 'read' by artists seeking alternatives, who developed other methods of funding and display.

29. Andy Warhol (born 1930): *Black and White Disaster.* 1963. Acrylic and silkscreen on canvas, 243.8 × 182.9 cm. (96 × 72 in.) Los Angeles County Museum of Art; gift of Leo Castelli and Ferus Gallery through the Contemporary Arts Council

This is not to discredit the role of bodies concerned with public patronage generally but to emphasize the fact that their bias precludes them from genuine commerce with advanced, innovative (and therefore 'risky') work, particularly if it advocates political or social change even by implication. Clearly only such organizations with their vast resources could put together many of the international shows which so shaped our culture, but it is objectionable that these tended to conspire

43

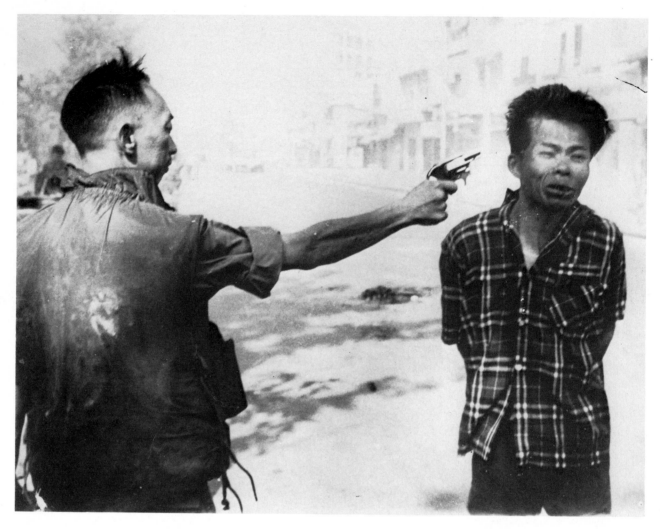

31. Saigon Execution. 1968. Photo: Eddie Adams. Courtesy of Associated Press

to hallow the safe and the established. The United States Information Services' shows, 'Modern American Painting' of 1961, and 'Vanguard American Painting' of 1962, were invaluable in showing Britain what was going on, but there were other developments of great significance which had no hope of establishment aid to facilitate their exposure.

The debate continues about the relevance of many alternative forms. The debate about what happens on the canvas is too incestuous an art-world one to affect anyone else but the sixties were successful in that they eroded the

public's resistance to hybrid forms. The high-camp rejection of technique, sometimes in favour of a deliberate shoddiness, which aped that of mass production, initially confused people, then altered their expectations: 'The new art refuses in various ways to flow in the same channel as the old, yet it owes the public attention it receives to the old dogma of Art, One and Indispensable' (Jacques Barzun *The*

32. Wolf Vostell (born 1932): *Miss Amerika*. 1968. Photo and screenprint, laminated on canvas, 200 × 120 cm. (78¾ × 47¼ in.) Cologne, Ludwig Museum

44

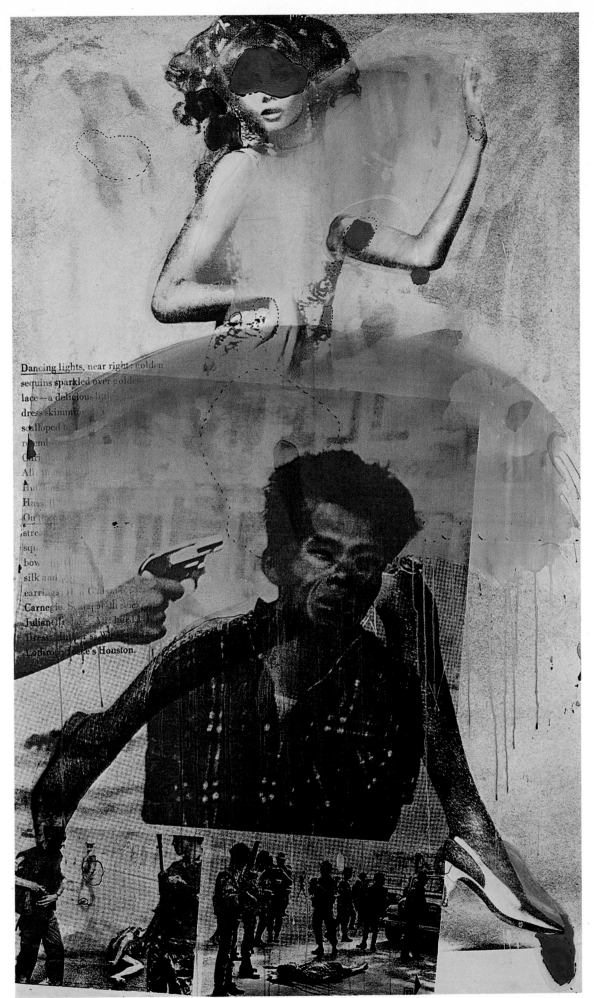

Dancing lights, near right: golden
sequins sparkled over golden
lace — a delicious lime
dress skimming
resembl
Cari
All
hu
Ha
On
stre
squ
bow
silk and
earrings
Carnegie
Julian
Dress
Lothrop ocke's Houston.

45

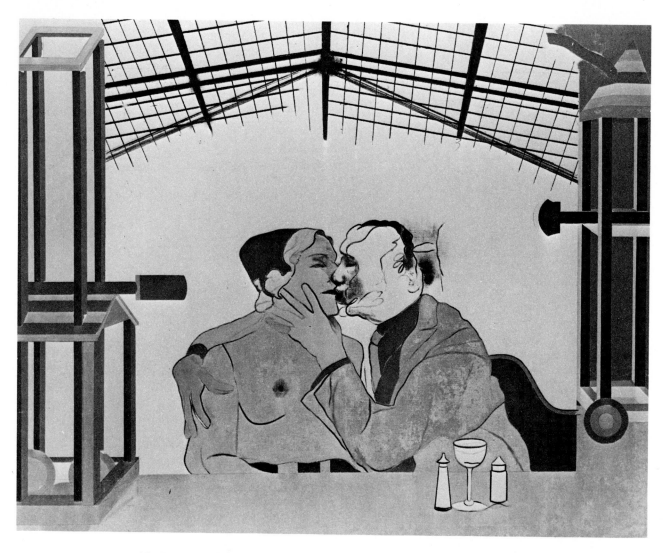

33. R. B. Kitaj (born 1932): *Where the Railroad Leaves the Sea.* 1964.
Oil on canvas, 122 × 152.5 cm. (48 × 60 in.) Artist's collection

Use and Abuse of Art. The debate among the *cognoscenti* changed gradually, so that by the early 1970s there was an emphasis on art's social role. Again there is a paradox in that Pop art, a most suitable vehicle for the articulation of social and political dissent, failed to concern itself with radical change, despite the fact that it was a pop mode that was exploited for political purposes in South America, in France, Spain and Italy. In the United States some artists have expressed social concern, for example in their treatment of violence, Kienholtz, Oldenburg, Kaprow and Segal might be regarded as amongst these, but it is arguable that their dissent was expressed to insiders—exploiting social and political problems—rather than acting as a tool in the resolution of them. On the whole artists were content with only passing references to the great issues of the time, and may well be considered to have fiddled while Rome burned. How else can we regard such a wholesale retreat from real life as when Minimalist Art was produced in a country

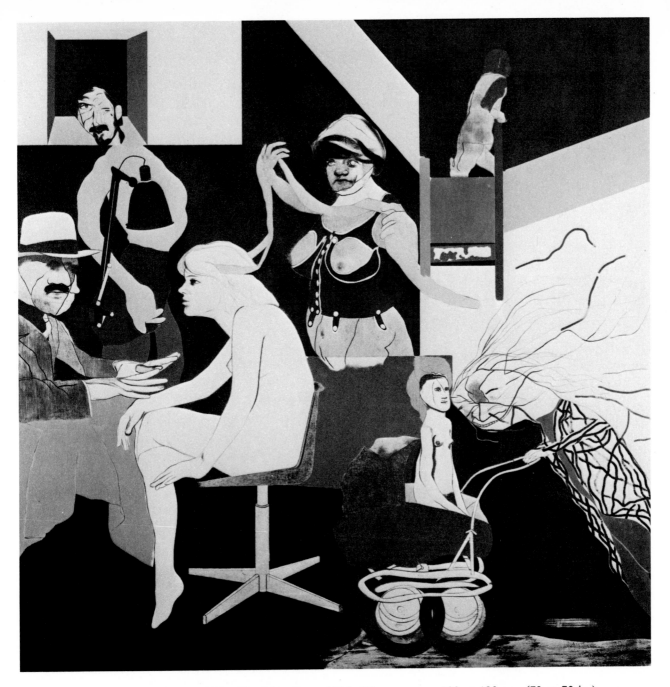

34. R. B. Kitaj (born 1932): *The Ohio Gang*. 1964. Oil on canvas, 183 × 183 cm. (72 × 72 in.)
New York, Museum of Modern Art. Courtesy of Marlborough Fine Art Ltd

indulging in a vile and immoral war? That was the cry of those students who rioted at the Venice Biennale of 1968, but they were among the few; their cry was echoed by students who took over that year's 'Documenta' press conference: 'Art serves the freedom of man, and it is in this sense that art and politics are related. Western Democracy needs the cultural affirmation of exhibitions like 'Documenta' to reinforce its value system. Abstract art demonstrates the moral indifference of the capitalist society' (Lynda Morris, 'What is it that made the Sixties' Art so successful, so shallow?').

For the major survey exhibition of British Art 1960-1976 in Milan in 1976, the catalogue

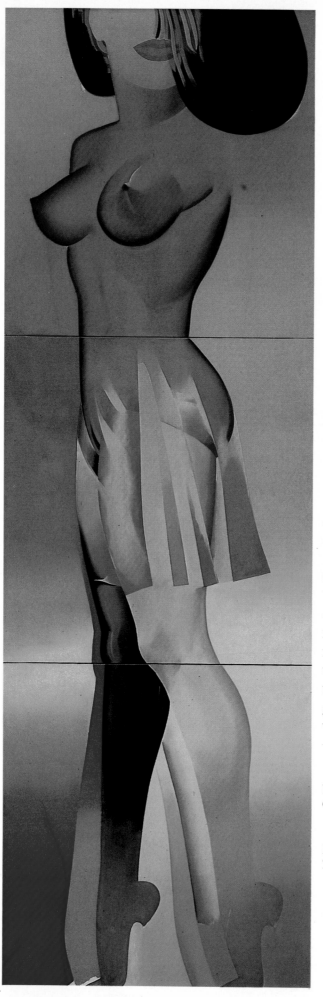

was divided in two. In part one (by far the larger) Norbert Lynton wrote an essay 'Painting: Situation and Extensions.' The second part contained an essay 'Alternative Developments' by Richard Cork. In the arrangement of the catalogue there was an implication of the 'mainstream' and the 'secondary', but as it turned out even the former admitted a pluralistic approach. Lynton dealt favourably with John Latham's 'paint objects' and Mark Boyle's category denying activities. Unfortunately Lynton's benignly catholic approach to admissible art practices was spoiled by criticism of those who had avoided the production of the object: 'objectless art has placed every sort of burden on the artist himself. Art is not an object he delivers; therefore it is what he thinks, says, performs; he is art himself. The dangers, the temptations are many. Showbiz beckons, and it takes a strong and austere spirit to evade the fashionable political platitude, the ingratiating joke, the self-glorifying obscurity'. This comes strangely from one who has assimilated the carnival cavortings of pop and himself devised an exhibition of Minimalist art. He was answered by Cork (quoting E. H. Gombrich: 'Art with a capital 'A' has no existence'), liberal in his tolerance of unorthodox art activities, who actually indicted some anti-object artists for not moving away from the market-place as far as their opinions might seem to dictate. If we also take Gombrich's advice that 'there is no greater obstacle to our enjoyment of great works of art than unwillingness to discard

Left: 35. Allen Jones (born 1937): *Perfect Match*. 1965. Canvas, in three sections, 280 × 93 cm. (110¼ × 36½ in.) Cologne, Ludwig Museum

Right: 36. Robert Rauschenberg (born 1925): *Break-Through*. 1964. Lithograph, 104.8 × 75.6 cm. (41¼ × 29¾ in.) Leo Castelli Art Gallery

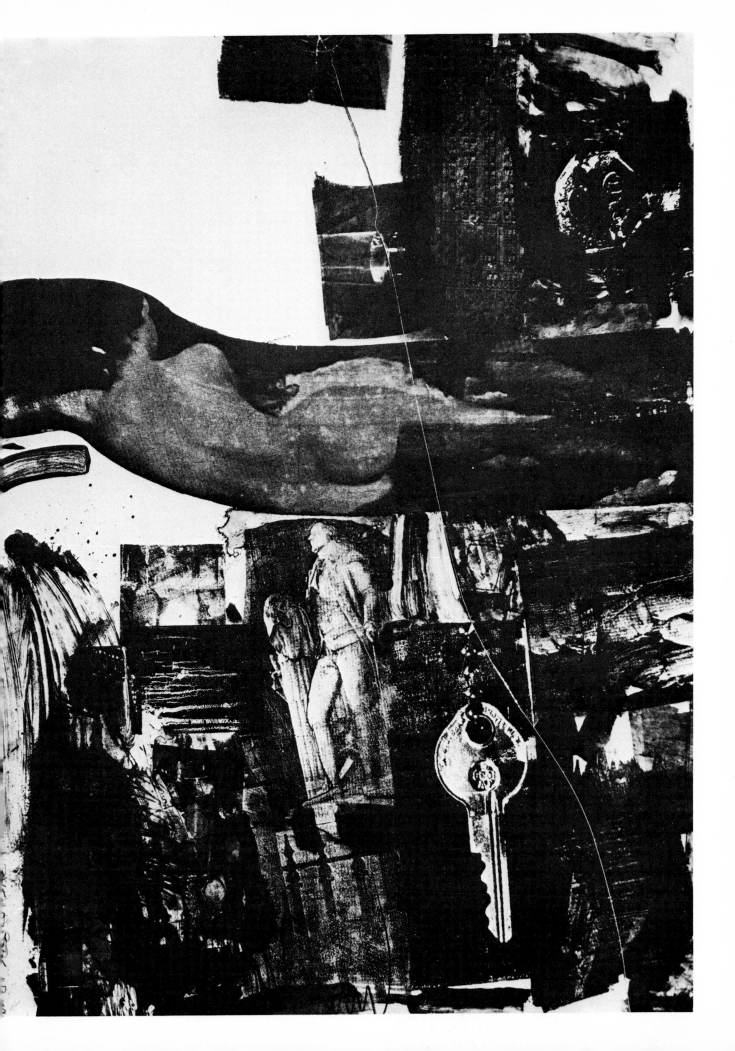

37. Ellsworth Kelly (b. 1913): *Green, Blue and Red*. 1964. Oil on canvas, 185.4 × 254 cm. (73 × 100 in.) New York, Whitney Museum of American Art; gift of the Friends of the Museum of American Art. Photo: Geoffrey Clements

38. Louis Morris (born 1912): *Gamma Delta*. 1959-60. Synthetic polymer on canvas, 258.4 × 387.4 cm. (102¾ × 152½ in.) New York, Whitney Museum of American Art; gift of the McCrory Corporation

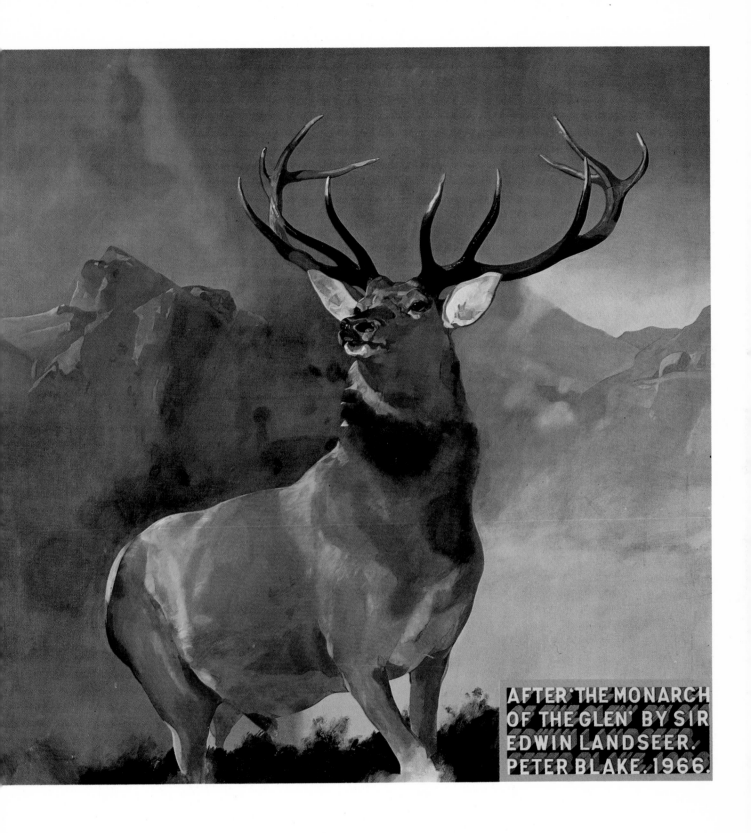

39. Peter Blake (born 1932): *After 'The Monarch of the Glen' by Sir Edwin Landseer*. 1966.
Cryla on canvas, 121.9 × 121.9 cm. (48 × 48 in.) Private collection

habits and prejudices', we might find no obstacle in accepting that what was exciting and intellectually stimulating in the art of the late sixties was not in the galleries, however alternative, but in the streets: wall posters, press-photographs, whether of overturned cars or Abbie Hoffman's arrest, pose far more invigorating and relevant cerebral problems than the contents of the gallery. Considering that the basis of the mass of sixties art was its contemporaneity, and the expression of the experience of man as part of a complex modern social organism and the objectification of his relationship with the harsh, vulgar realities of the modern world, its divorce from the realities, seems shocking. In looking at the considerable offerings displayed as art, one is amazed that there is such scant evidence of contemporary social upheavals. One can argue further that not only is the overt expression of social trauma missing but it is entirely absent even as metaphor.

As a prelude to the remedy of modern ills an examination of the conditions in which they developed is salutary. We are in the middle of one of our periodic bouts of nostalgia for a fancied golden age. The poverty of the present leads us to confuse the opulence and prolificacy of sixties art activities with true value under the mistaken impression that it was a rare period of rapport between audience and artist. We are now sufficiently distanced from the period to recognize its main features and to determine their significance for their lineally descendant forms, and we are not so much out of sympathy with the spirit of the time as to fail to recognize the subtlety of its problems. Renewed interest in sixties work abounds as I write. Edwin Mullins, speaking on BBC Television's *Arena: Art and Design* on the 1977 'Documenta' exhibition, saw the sixties as the time when the lionization of the artist began a process of social re-integration and current

debate has concentrated on either work produced during the 1960s, recently shown, or contemporary work in a sixties idiom. Battle lines have been drawn between advocates of figuration and representation who have taken issue with the formalist/abstractionist crowd. The latter have found strange allies among those involved with intermedia activities, and naturally opinions have polarized along political lines.

The debate began in 1976 when Ronald Kitaj purchased works forming the Arts Council exhibition 'The Human Clay'. Kitaj, in a mood of chauvinist euphoria, wrote of the emergence of a vigorous 'School of London' in his catalogue essay. Peter Fuller took a more dyspeptic view and wrote of 'sweaty life class traditionalists, those who still wear Euston Road spectacles', and of the works' 'quaintness', dismissing most of sixties art as overestimated because it 'failed to transcend the prevalent illusions of late 1950s and early 1960s, the ideology of the Affluent Society'. He admitted the relative vitality of such work and its cultural effectiveness (in that the work got wide currency via exhibitions, articles in popular magazines, and through its filtration into fashion and design). Later Peter Blake, the doyen of British art in the early sixties, engaged with Richard Cork who had criticized the irrelevance of expensive latter-day pop to contemporary society. His argument was unanswerable, coincident as it was with a massive return of the grand old men of the sixties, none of whom had anything particularly new to say. Hamilton, Dine, Allen Jones and Kitaj, all had British shows; Rauschenberg a major American tour; the Tate had an unashamedly nostalgic romp with its 'British Art of the Sixties'; the Fitzwilliam Museum, Cambridge, showed American art, preponderantly sixties; Battersea Park was full of sculpture (sculpture in parks was, as a result of civic affluence, almost a sixties

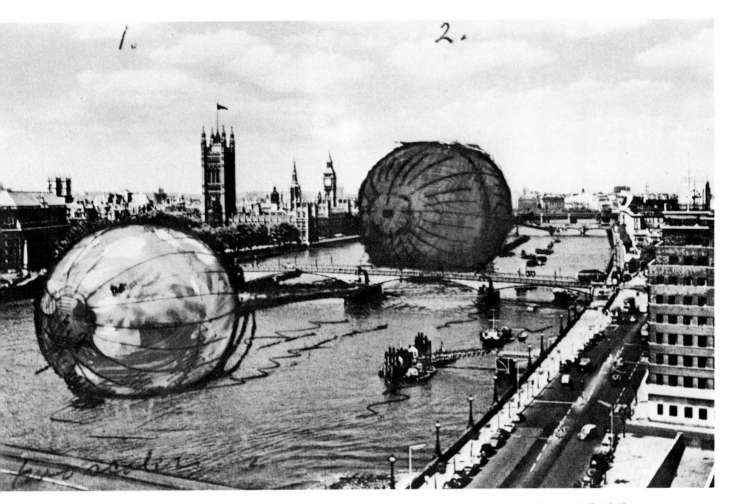

40. Claes Oldenburg (born 1929): *Proposed Colossal Monument for the Thames River: Thames Ball.* 1967.
Crayon, ink, watercolour on postcard, 8.9 × 14 cm. (3½ × 5½ in.) New York, Sidney Janis Gallery;
collection of Carroll Janis. Photo: O. E. Nelson

concept), and the Royal Academy showed 'The Cream of British Painting from the 50s to the 70s,' permitting themselves an unwitty pastiche of a Warhol soup can on their publicity handouts. Happy days were here again! The critics, happy to have something to stick their qualitative teeth into, heaved deep sighs of relief and waxed lyrical. All that exposure of sixties and quasi-sixties art demonstrated was that mainstream sixties art now seems tired and saggy, that it never embraced the shit and squalor of the world, but was simply a cosmetic devised by the consumer society to disguise reality.

Claes Oldenburg's rousing Credo was no more than a robust poem. Peter Blake's reiteration of the old chestnut that art always reflects the times and 'each generation of artists must search for an aesthetic vocabulary that relates to the realities of the time' was in the early sixties before the romanticism went sour. With a few pale, self-conscious exceptions, frivolity, optimism, even euphoria, mainly characterize them. Formalism and a hermetic concern with styling relate only very obliquely to the realities. The sheer exuberance of the art scene, the fact that more people were buying Kitsch art, ephemera, multiples, prints (all form and no substance) was all a vast façade, an unconscious contrivance to disguise the fact that capitalism had got out of hand. The optimism which greeted the acceleration

53

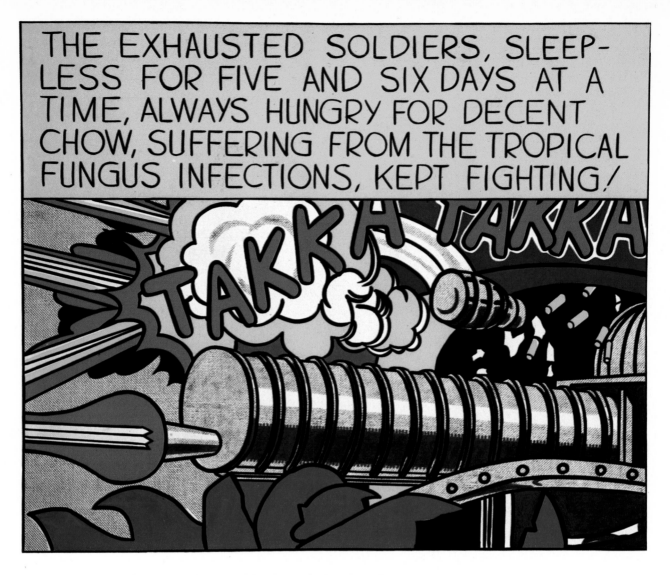

THE EXHAUSTED SOLDIERS, SLEEP-
LESS FOR FIVE AND SIX DAYS AT A
TIME, ALWAYS HUNGRY FOR DECENT
CHOW, SUFFERING FROM THE TROPICAL
FUNGUS INFECTIONS, KEPT FIGHTING!

41. Roy Lichtenstein (born 1923): *Takka Takka*. 1962.
Acrylic on canvas, 173 × 143 cm. (68¼ × 56¼ in.) Cologne, Ludwig Museum

of the flight from the concrete and static in art, in the very late sixties and early seventies, was the product of discontent with the situation. What has recently been called the 'Crisis in Art' is the result of the general flailing around and lack of persuasive theory caused by the failure of those initiatives.

Quite early in the sixties the vigour which characterizes the true avant-garde was played out, and one ceases to look for excitement within anything recognizable, according to traditional criteria, as 'art'. Those developments calling into question the whole of current art practice went unremarked, whilst planned obsolescence—rather than the genuine renewal of ideas, destroyed their serious predecessors. Significant cultural change there was; though not motivated by any single aesthetic or ideological stance. In *Violence in the Arts* John Fraser sees as the two most symbolic cultural events of the sixties the publication, in the same year, of Marshall McLuhan's *Understanding Media* and Susan Sontag's 'Notes on Camp'. The latter he describes as an '"apologia" for the sensibility of failed seriousness and the theatricalization of experience' on the part of the 'sophisticated queer underground'; he regarded it as a kind

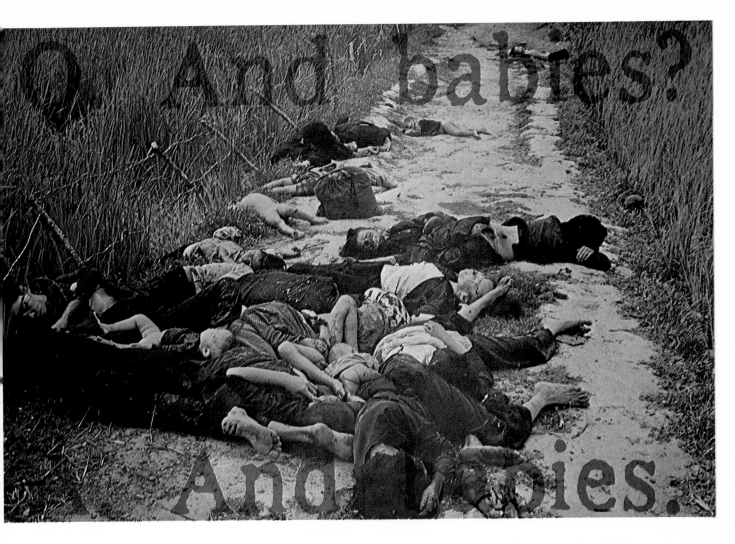

42. Poster from The Art Workers' Coalition, based on a photograph of the Song-My massacre. 1970. Courtesy of Marc Chaimowicz

of cultural *putsch* and held that both works subverted the normal critical process and indicated the general intellectual collapse which typified the sixties. The flimsiness of subsequent restructurings, and the difficulty of identifying them with familiar phenomena, caused uneasiness in conservative commentators and practitioners like Reinhardt, as they contributed to a general feeling of insecurity. Many of the problems thrown up have not been solved, nor has it been possible to place them as part of any coherent art historical continuum, and this neither devalues nor discredits them. What tended to do that was the superficial way in which their apologists treated them at the time. Unfortunately they emphasized style ('Notes on Camp' being as much about sexual styles as it was about aesthetics) and they tended towards an acceptance of what Fraser regarded as an intellectually weak, and rather silly, approach to contemporary cultural problems. The new intellectual and social freedoms did not result either in intellectual clarity or rigour, causing a wider admission of pluralism than hitherto; a pluralism that was not merely accepted but mandated, because there was no common recognition of what art was. Consequently

55

43. John Latham (born 1921): *Art and Culture*. 1966-9. Assemblage: book, labelled vials filled with powders and liquids, letters, photostats, etc. in a leather case, 7.9 × 28.3 × 25.4 cm. (3¼ × 11¼ × 10 in.) New York, The Museum of Modern Art; Blanchette Rockefeller Fund

artists, who were maintaining the debate about what art was. This quest took the path of a divergence from fixed forms, so that critics have categorized it variously as 'Anti-Object', 'Post Modern' and 'Post Object'. But the labels are irrelevant, it is the stance of the artist that matters. Generally he eschewed the personality cultivation of the established artist and usually opted for blankness and anonymity. For the most part he avoided confining himself to any single genre or medium and genuinely operated at the interstices of media, innovating in Kaprow's 'areas of impurity which remain after the usual boundaries have been erased'.

Jean Clay's repudiation of outmoded means of expression in 'Painting, a Thing of the Past' (*Studio International*) was even more categorical. His solution to the stale stasis of what he called the 'plodding daubers' lay in the attempts of certain artists, principally those involved in kinetics, to recreate 'the furtive climate of primitive society'. Whilst recognizing that there was bad kinetic work as well as some truly revolutionary painting, he postulated Kineticism as the artist's awareness of the instability of reality. The language of science had, in expressing such concepts as evolution, the universe, relativity, the fluidity and ductility of natural phenomena, intuitively been incorporated into the language of art. For him what was compelling about the new art was the instability of the medium: 'The metamorphosis is played out in the heart of the material which bears the message of the work', which ceases to be a mere static depiction or evocation of reality *re-presented* by the conventions of art, but a re-enactment or actual aesthetic event happening before the

there were many levels of experience, and such ramified praxis as to render intolerance impossible. Mass consumerism, rather than social concern, being art's prime conditioner, it was regarded by the majority as just another fairground, and the provider of a merely temporary stimulus. An art that tickled the fancy and had its basis in high camp fashion proved insufficiently abrasive to act as catalyst in even a modest revolution.

Yet there were those who were earnestly seeking to enlarge the imagination, people who were seeking to forge radical new modes of expression, and it is these who were enriching a dark age. It was they, and 'establishment'

44. Christo (Javacheff) (born 1935): *Package*. 1961. Fabric, plastic, twine, rope and wood, 91.5 × 63.5 × 36 cm. (36¼ × 25 × 14¼ in.) Artist's collection. Photo: Eeva-Inkeri

56

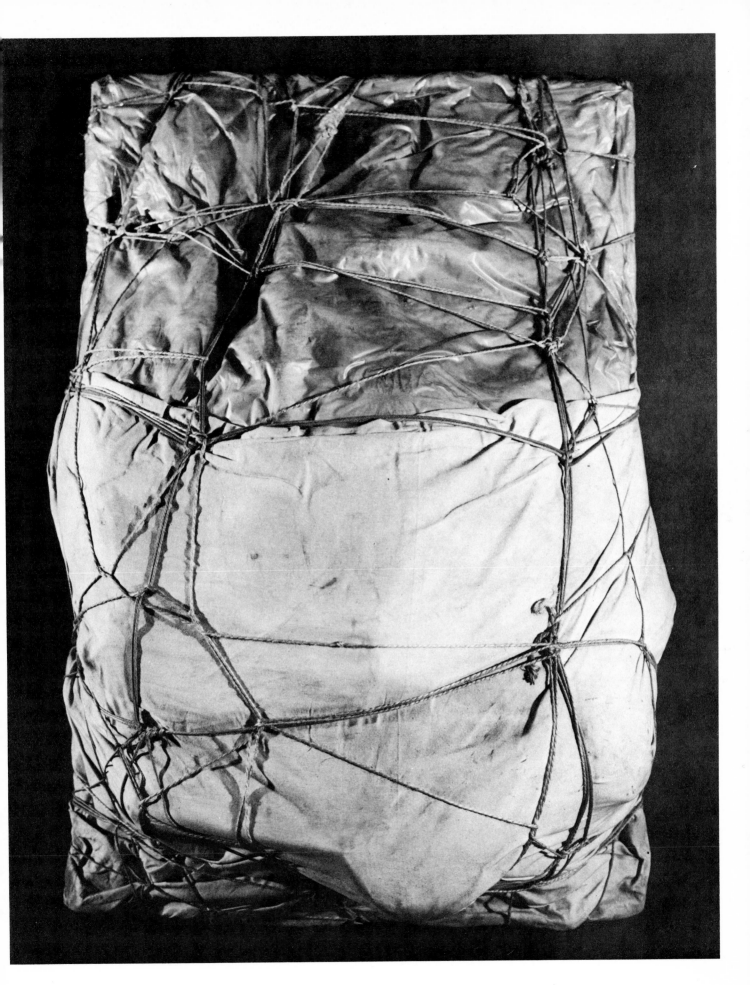

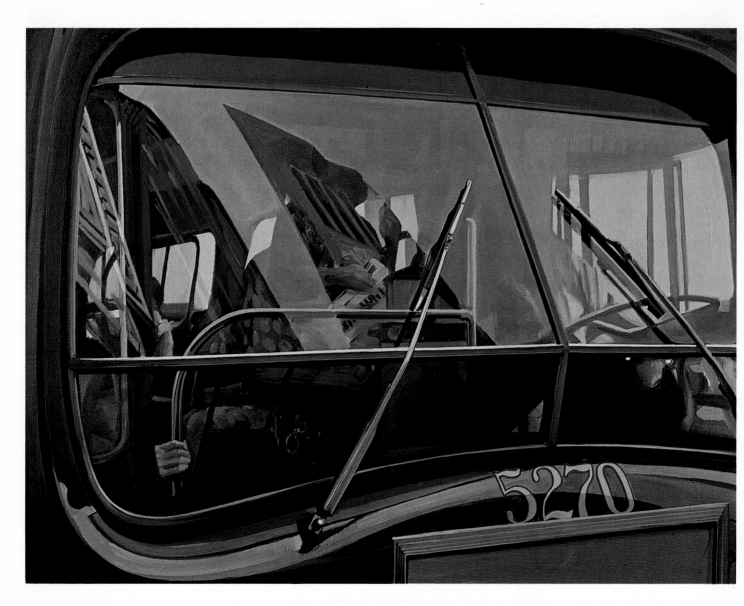

45. Richard Estes (born 1936): *Bus Window*. 1969.
Acrylic on canvas, 62 × 84 cm. (24½ × 33¼ in.) Aachen, Neue Galerie. Photo: Anne Gold

viewer: so the work is seen as it is—in a constant state of flux. Clay draws a grammatical parallel by saying that the kinetic work is in the *present tense*, whereas a conventional painting—whether landscape or abstract composition—is in the *past tense*, as it simply represents a transposition of a previously experienced reality.

Lucio Fontana had recognized much earlier

that Kinetic, or time-based art, required technological advances which would fundamentally reorganize man's perceptual capacities. For Fontana the integration of plastic art and motion were inseparable necessities. In a manifesto of 1962 he wrote:

Art is passing through a latent period. A force exists which man is unable to express . . . It is for this reason that we are asking all men of science

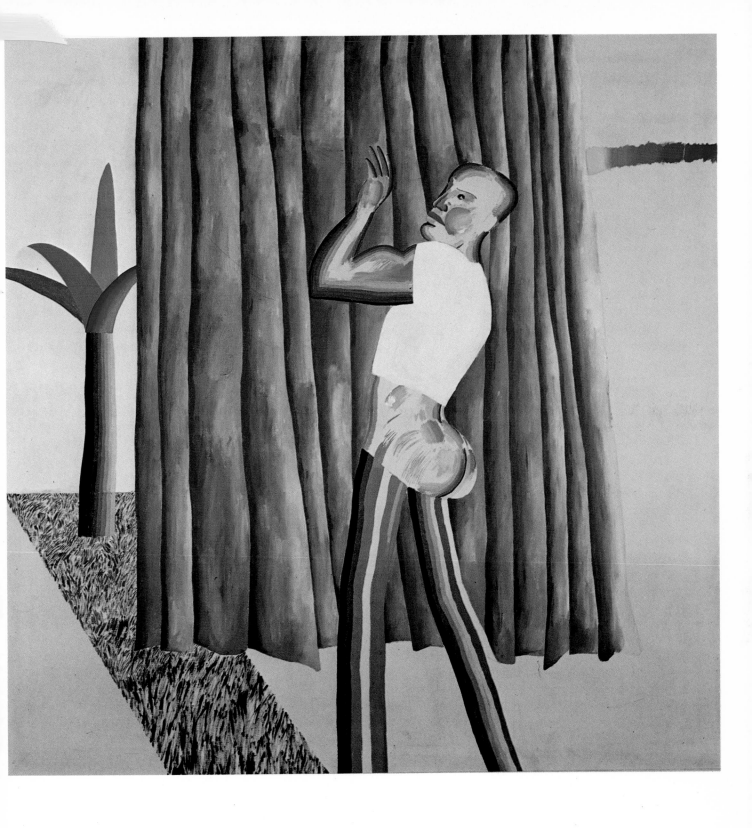

46. David Hockney (born 1937): *Cubist (American) Boy with Colourful Tree*. 1964. Acrylic on canvas, 167 × 167.6 cm. (65¾ × 66 in.) Washington, Hirshhorn Museum, Smithsonian Institution. Photo: John Tennant

throughout the world, who are conscious of the fact that art is a vital necessity for the human race, to orient a part of their research towards the discovery of luminous and malleable substances and the sound producing instruments that will make possible the development of tetra-dimensional art.

Fontana catalogues the artist's inability to reconstruct the dynamism of the world, and saw the answer in a fusion of scientific and artistic modes into a synthesis capable of developing into a space-time art. He was a precursor of Kinetic art; his 'non-sculptures'—plastic use of neon light—literally showed the way to a younger generation wishing equally to exploit the optical stimulation in the Kinetic artworks that Clay saw as continuing events constantly evolving through time. For him it was the universe in micro-cosm, he claimed: 'Kineticism is not realistic art, it is the art of reality.' The dynamism of

Kinetic art was not a new phenomenon, it had been anticipated a number of times this century by Duchamp, Gabo, Calder etc., but none of them condemned so explicitly the old media—'media such as stone or oil paint which cannot reflect the ductility and instability of the changing world . . . While the fetishistic champions of Pop art and Neo-Dadaism indulge in their pious attempts to safeguard the products or the debris of a consumer society in their desperate endeavour to fix the appearances of the world around us which is breaking up on every side, the Kinetic artists accept this decomposition and use it as an integral part of their message.'

Clay's definition of 'Kinetic' was a catholic one, embracing as it did artists such as Yves Klein and Fontana to whom one might well assign other categories. In his dismissal of the fixed, static medium is a condemnation of

47. Donald Judd (born 1928): Untitled (Eight modular unit, V-channel piece). 1966-8. Stainless steel, 20 × 313 × 318 cm. (7¾ × 120 × 122 in.) Cologne, Ludwig Museum

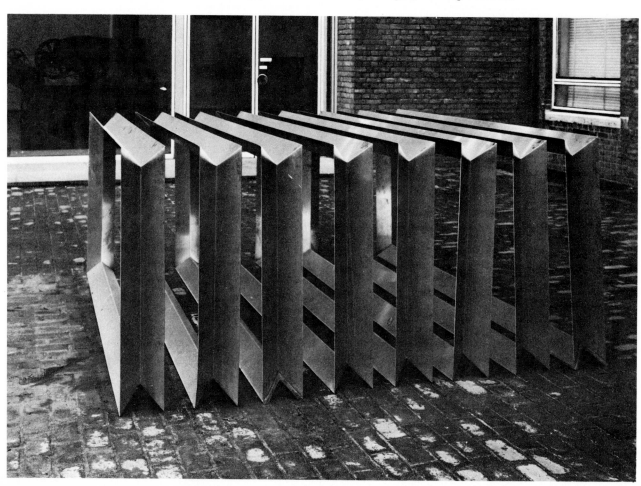

48. Jean Tinguely (born 1925): Sketch for '*Homage to New York*'. 1960. Felt pen and ink on Bristol board, 56.2 × 71.1 cm. (22⅛ × 28 in.) New York, Museum of Modern Art; gift of Peter Selz

formalism which he believed was anticipated implicitly in the work of Mondrian in 1918 and 1942; in 1925 by Albers; by Soto, Morellet and Vasarely in the fifties, and later by the Groupe de Recherche d'Art Visuel. The balancing of forms and the equilibrium of volumes were seen as redundant activities, the energization of the optic nerves of the specta-tor by Kinetic art being deemed to render all visual apprehension of coherent hermetic forms impossibly obsolete. Thus there were two schools of thought, united in their condemnation of conventional modes of ex-pression. Their common ground was in their recognition of the importance of movement and of the gesture. Clay's definition of Kinetic allowing it to embrace the work of Gustav Metzger, Yves Klein and Lucio Fontana, provides an indicator that their common interest was in a crusade against the durable object which enshrined for ever a frozen moment of creativity and also accreted value. Allan Kaprow's condemnation of 'per-manence' in art and his use of perishable

49. Derek Boshier (born 1937): *The Identi-Kit Man.*
1962. Oil on canvas, 62.2 × 80 cm. (24½ × 31½ in.)
London, Tate Gallery

50. Victor Moscoso: *The Miller Blues Band, Fillimore.*
1967. Poster, screenprint, 50.5 × 35.9 cm. (19¾ × 14¼ in.)
San Francisco, Thackrey and Robertson Gallery.
Photo: G. Roberton

quence, producing, as he does, for a culturally formed bourgeois minority, and acquiescing in their games and assumptions. He felt the tolerance of the bourgeois public for even mentally and politically subversive art to be high. They were titillated by it and, after all, it was no threat hung on their walls. Buren criticized the artist for believing in the 'myth of revolutionary art' at a time when art was an ornament of its antithesis. Rather than a harbinger of change for the good, art boosted the *status quo* and was 'objectively' reactionary. The role of the artist was therefore evil. Buren's criticism of art reveals the intrinsically diseased relationship it had with its host society:

> The system is not afraid of seeing art in the factories. On the contrary. The enterprise of alienation will be complete when 'anyone' can participate in culture. For culture, and art, such as they are currently conceived, are certainly the alienating element . . . here we discuss the political and even intellectual virtue of art: *distraction*. Some art is only illusion, illusion of the real; it is necessarily distraction from the real, a false world, a false semblance of itself. 'Art is the blindfold over the spectator's eyes which allows him not to return to his reality or the world's reality' (Michel Claura) . . . Art is the safety valve of our repressive system. As long as it exists, and, better yet, the more prevalent it becomes, art will be the system's distracting mask. And a system has nothing to fear as long as its reality is masked, as long as its contradictions are hidden. Art is inevitably allied to power . . . today it is so obvious that 5,000 policemen are sent to defend an avant-garde biennale.

Obviously the end of the art-object alone would not satisfy Buren. The pervasiveness of capitalism is indicated by the fact that his anti-gallery, anti-art, statements are still being exhibited in art galleries. In 1976 he had an installation at the Institute of Contemporary Arts London, which did not significantly differ from his work of ten years earlier. People persist in seeking art.

Buren's polemic, if extreme, reflects a growing opinion during the late sixties. As the emphasis on the concrete and static object which had persisted for over twenty years waned, it gave way to two main tendencies. The one that made greatest impact was the least accessible: an art that emphasized the thinking process (this was only partly a response to political imperatives), the artist became a thinker, rather than a maker. Increasingly during the fifties and early sixties the artist had simply designed his objects—whether paintings, sculptures or prints—leaving them to be executed by craftsmen, consequently the artist came to recognize that making *per se* had no value. The second development was the art action, whether it took the form of Kinetic Art or Happening, as described by L. Lippard and J. Chandler in 'The Dematerialization of Art' (*Art International*):

> The visual arts at the moment seem to hover at a crossroad that may turn out to be two roads to one place, though they appear to have come from two sources: art as idea and art as action. In the first case matter is denied, as sensation has been converted into concept; in the second case matter has been turned into energy and time-motion.

In *Art-Action and Participation*, Frank Popper has developed a schema substantially indicating the same opinion. He identified three mainstream 'traditions' in twentieth-century art. The first he called 'Post Dada': it included Pop Art, Conceptual Art, the various anti-art manifestations, and Hyper-Realism. Secondly he recognized a 'Post Bauhaus/Post-Constructivist' line, including art in architecture, art in the environment, science in art, and technology in art. The last phenomenon on each continuum was 'Civic and Public Art', which he saw as the end result of all three of his mainstreams—a genuinely democratic art. Public/civic art he linked to what Dr Roger Cardinal has called 'Outsider art', i.e. primitive art, naïve art, the art of the mentally ill

etc., which was at the end of his Post-Dada continuum. His third line of activity between and linking the two mainstreams he called 'Post-Art Social'. The lineal development in this case he traced via production art and various forms of political art, including Socialist Realism, to spectator participation, which, whether accepted as 'art' or not, is comparatively recent manifestation. In Britain many of the activities in this category are now called 'Community Arts'—murals, art in the street, actions, inflatables etc., but he also included poster art, Pop art, and the demotic, ubiquitous, graffiti. All these he saw as drives towards a genuine democratic art so long sought. His hypothesis is interesting because it parallels Lippard and Chandler's dematerialization thesis, and recognizes the scientific/technical basis of Kinetic and Optical Art and the organic/humanist one of Post-Dada activities (like the Happening and the Environment) as rooted in common ground. Furthermore it firmly identifies them as part of a reaction against hermetic, formalist values and a general impulsion towards a democratic, and *ergo* political, art. No one has spoken of this as vividly as Daniel Buren:

> The artist appeals to laziness, his function is emollient. He is 'beautiful' for others, 'talented' for others, 'ingenious' for others, which is a scornful way of considering 'others'. The artists bring beauty, dreams, suffering to their domiciles, while 'the others' whom I myself consider *a priori* as talented as artists, must find their own beauty, their own dream . . . Perhaps the only thing that one can do after having seen canvas like ours is total revolution (Andre Parinaud's 'Interview with Daniel Buren'. *Galerie des Arts*.)

The value of the alternative means of expression which grew in the sixties was that they introduced the possibility of the obliteration of the undesirable aesthetic object. Ephemeral works and gestures, spontaneous and more democratic modes became possible with the destruction of the

53. Poster produced by Association of Members of Hornsey College of Art, 1968

frame. The all-enveloping spectacle marked the breakdown of rigid historical categories of activity and introduced the possibility of mass participation with all its connotations of non-conformism, freedom and political impulsion. One should not underestimate the importance of this if the aim of art is the liberation of a general creativity lying innate in everyman. The creed of the *Nouvelle Tendance* encapsulates this philosophy:

> 'Our aim is to make you a partner. Our art is based on reciprocity. It does not aspire to perfection . . . our art depends on your active participation. What we are trying to achieve is for your joy before the work of art to be no longer that of an admirer but of a partner.

67

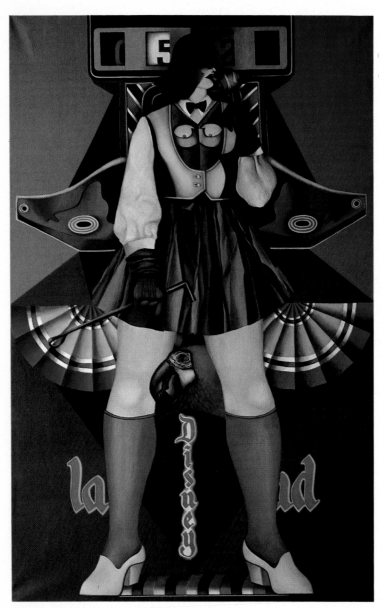

Often in the alternative modes the emphasis was on *action*. Historically this can be seen as continuing where Jackson Pollock left off with gestures of total engagement. The incestuous art-debate, now resumed, was abandoned entirely in the late sixties and replaced by the socialization and politicization of art. This return to earlier twentieth-century concerns, the repudiation of the academy, the museum and the gallery, seems familiar. The death of art—a fifty-year-old theme—was again re-iterated, and there was an effervescence of genuinely democratic, demotic expression, in wall paintings, posters and performance-actions, of great vitality. This represented the true renewal of the avant-garde and is almost the only area of sixties art possessing lasting value, being the only area in which compelling innovation was taking place. Jean Dubuffet claimed, in *L'Asphixiante Culture*, that 'The characteristic property of an inventive art is that it bears no resemblance to art as it is generally recognized and in consequence—and this is more so as it is more inventive—that it does not seem like art at all.'

In the words of Anton Ehrenzweig in *The Hidden Order of Art*, art had 'arrived at the paradox that tradition itself required the occurrence of radical attacks on tradition, which, to quote Harold Rosenburg, took the form of 'casting aside—sharply crystallized modes of rational thought and image making' (*Art on the Edge*) that characterizes a truly inventive art, and which makes demands of the creativity of artist and audience alike. This desire, especially on the part of the young, to build a new society based on equality and individual responsibility was the 'anti-bureau-cratic, anti-gangster, anti-violent society,' of which Yevtushenko wrote in the *New York*

54. Richard Lindner (born 1901): *Disneyland*. 1965. Canvas, 203 × 127 cm. (80¼ × 50 in.) Cologne, Ludwig Museum

55. Jim Nutt (born 1938): *Miss E. Knows*. 1967. Acrylic on plexiglass with collage elements, 190.5 × 130.2 cm. (75 × 51¼ in.) Chicago, The Art Institute

56. Poster distributed by students in Paris during *les événements de mai*, 1968

Times. This again reflects early twentieth-century movements depending on a free play of the imagination:

> 'Imagination takes command' . . . an art that takes the form of open-ended unplanned Happenings, plays an important part in this process, varieties of experience that transcend knowledge are decisive. Artists' rejection of a materialistic point of view all over the world indicates a growing trust in psychic, magical, and mythic values. Everything is related to everything else (Udo Kultermann, *Art Events and Happenings*).

The revolt of the young all over the Western world in the mid and late sixties reached its apogee in Paris during May 1968. The irrelevance of art in its traditional forms was fervently demonstrated by the mechanical ballet of the riot police, the theatre of the streets and the exuberance of political posters. The museum curators locked their doors. Youth's brief rejection of the idiocies of a materialistic consumer society, and the affirmation of its dignity through the embracing of Eastern mysticism, and its non-conformity through soft drugs and the whole paraphernalia of hippiedom, was rapidly exploited by the scions of capitalism, but for a heady moment McLuhan's global village became hazy and incense-laden, as the love-

generation exerted international flower power.

Success was failure, for international, love-laden dissaffection amongst the young became too much of a threat, accompanied, as it was, by a good leavening of intellectual rigour. The powers-that-be moved, none too gently, and squashed it. Che's dictum that the 'true revolutionary is guided by great feelings of love' captivated the hippies, who took to the streets. Earlier romantic affirmations of togetherness (everything related to everything else) were quickly re-appraised:

> These relationships are not static, they are continually in the process of becoming. The circulation of the blood, electric current, sexual and cosmic interpenetration, intellectual, physical, emotional and mythic insights flow into a new, human current of values, an ethic based upon love and mental help, the sign of another epoch. The culture of the sixties shows the way (Udo Kultermann).

But the young and the black, and the dispossessed generally were impatient and their ideological stance shifted towards 'righteous violence,' which increased 'as an adjunct of black power anp a romantic infatuation with guerilla warfare', wrote Theodore Roszak in his essay 'Youth and the Great Refusal'. He described the late sixties counter-culture as the latest development in a major tradition in Western social and intellectual history, comparing it with Romanticism 'the first great assault on the scientific world view and the conception of personality which flowed from it'. Kaprow talked of the 'object's blank, empty silences' being 'hyped-up in the psychedelic dissolves of op, with both sharing in a quasi-technological sensibility that excluded handwork and individualized personality' (*Assemblages, Environments and Happenings*). The strange combination of nostalgia for *fin-di-siècle* decadence, allied with a dash of psychedelic mysticism and total engagement with current social and political

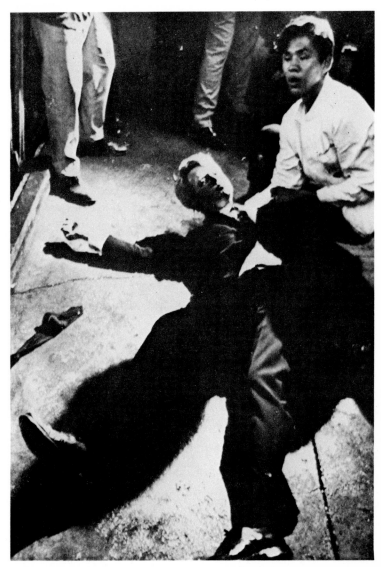

57. Senator Robert F. Kennedy on the floor of the Ambassador Hotel, Los Angeles, moments after he was shot. 1968. Photo: Boris Yaro, *Los Angeles Times.* Courtesy of Associated Press

problems is another peculiarity of a very eclectic time. Roszak wrote of the overlap between the counter-culture of the sixties and the English and French 'decadents'. He listed the constellation of 'vices' they had in common: drugs, eclectic mysticism, *outré* sexuality, and quoted Lawrence Gowing's description of Aubrey Beardsley to underline his point: ' "The prophet of the heightened hallucinatory rhythm . . . forerunner of the psychedelic flux and its liberated bi-sexual languor".'

The difference between the two attitudes is significant: the decadents in their decadence flirted with damnation whilst to the young of the 1960s their own gestures were a proclamation of rightness, self-expression, freedom—even sanctity. This, Roszak ascribed to oriental religion giving sanction to psychedelic and erotic bliss at the expense of former Christian guilt. The affinity between the new counter-culture and Romanticism (the 'imagination's taking command' echoes Faust's 'Feeling is all') is an interesting one, for not only does it permit the liberation of the individual, but contributes to the erosion of types and precedents which formerly characterized art. Roszak pointed out similarities between the thoughtless, essentially conformist histrionics of youth counter-culture, and the similar extravagances of fascism. He gave the example of Hitler's phrase 'Think with your blood' to indicate how Romanticism might degenerate into one of the principal ingredients of Fascism and recognized, on the fringes of the soft 'feminine' counter culture, a 'worrisome fascination with violence-minded phenomena like the Hell's Angels and James Bond movies . . . with the chichi sado-masochism of Phoebe Zeitgeist and Barbarella'.

It is remarkable how the undertow of violence was mainly reflected in bad art. Its treatment in painting and even hybrid forms seems pallid besides the astonishing impact made on the popular imagination by the efforts of a few photojournalists. It is they, with a few television cameramen, who really stirred the conscience of a nation, so that it is not too extravagant a claim that conventional 'fine-art' modes of representation became redundant as social and political catalysts, and as far as reaction to world events was concerned. The initiative moved to more flexible and instant media including the photo-screen printed wall poster. The efforts of

58. Mel Ramos (b. 1935): *Hippopotamus*. 1967. Oil on canvas, 180 × 247 cm. (71 × 97 in.) Aachen, Ludwig Coll.

59. Poster produced by Association of Members of Hornsey College of Art, 1968

metaphysical, rather than a social dimension. This effort to merge art with reality is the ritual vanguardism that Harold Rosenberg recognizes 'as advance having been deemed to take place to the degree that art divested itself of its own characteristics'. And it is this ritual vanguardism that passed for true action, taking the form, for example, of an introverted debate concerning formal aesthetic problems. The shape of the canvas and the depth of the colour field were esoteric concerns, art for its own sake of the most indulgent and effete kind, and of about as much relevance as the debate about how many angels can dance on the point of a pin.

The artist became in the process a beautifier of society, a paperer over cracks instead of an *agent provocateur*. Rather than resisting the forces which conspired to prevent him acting as social and cultural catalyst he sold out, and art continued precious, private, privileged and profitable, with the merest dash of precocity thrown in. If art related to life, it was, despite its quasi-popular images, private, safe, anaesthetized and hygenized.

It is hard to resist the eventual emasculation of what is robust. After all we have been long used to Dadaism and Surrealism being shown in the mausoleum-museums (to which their creators so vehemently objected), roped off and as well curated as the high art of the past. The Dadaist and Surrealist episodes were of immense value, being examples of periodic recurrences in which the critical faculty of the artist becomes so vehement and virulent that it seems to be predominant. This is also the case in the late sixties—perhaps as a reaction against the prevailing blandness; though there were periodic resurgences of the same spirit throughout the period. In a prophetic statement of 1952 (*Un Art Autre*) Michel Tapie recognized that art needed to 'stupefy to be art, at a time when, for the best reasons and the worst, everything is brought into play to

artists working in more cumbersome forms seem predestined as 'museum milestones'— formal marks of the historical process or ineffectual gestures, as the initiative passed elsewhere.

One of the main pleas of the disaffected students during the period of turbulence in Paris 1968, when almost all existing authority was questioned, was 'Freedom to Create'. Implied was that 'freedom' would involve the dismantling of the existing art-market/art display systems, as part of the destruction of existing political power. The European situation differs significantly from the American, where the 'problem' of life's relationship with art has always taken a

74

explain art, to popularize and vulgarize it, to get us to swallow it down as a complement to our everyday living, the true creators know that the only way for them to express the inevitability of their message is through the extraordinary—paroxysm, magic, total ecstasy'.

It is in the light of this that it is necessary to examine those themes in sixties art that have most significance in the light of subsequent developments. Largely this means avoiding what one might characterize as *beaux-arts* activities—using it to denote areas of work in, or deriving from, traditional mainstream activities. It also involves the recognition of a new tradition having its roots in the subversive, random, intuitive modes of Dadaism and Surrealism, and continuing to place emphasis on the gesture and the action, with varying degrees of both transitoriness and iconoclasm.

'Happenings' fall into this category. They have been variously defined. Al Hansen saw them as a means to integrate artist and audience and to reassert the pre-Renaissance role of the artist. He claimed that their reputation for being ultra-experimental and crazily theatrical has led to a misunderstanding of their nature. 'Contrary to the public's conception, the majority of happenings are quite formal, are very carefully rehearsed and do not invite any audience participation at all' (*A Primer of Happenings and Space/Time Art*). Allan Kaprow sees them as a logical step away from the flat rectangular field of a painting. The gestures and dribblings of Jackson Pollock, Tobey and De Kooning were movements of *total* involvement. Pollock's urgency of *gesture* was more important than the

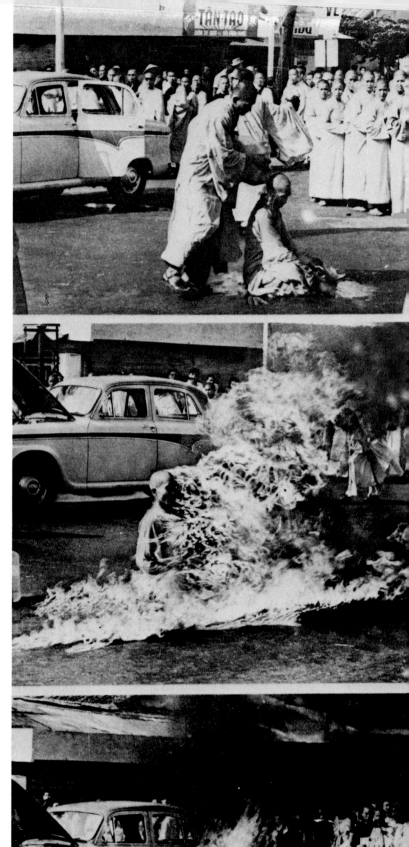

60. Buddhist Martyr. The Reverend Quang Duc, a 73-year-old Buddhist monk is soaked in petrol (top picture) before setting fire to himself and burning to death in Saigon. 1963. Photo: Associated Press

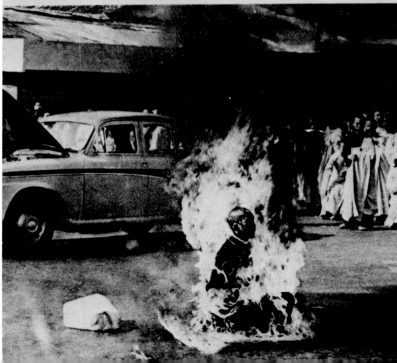

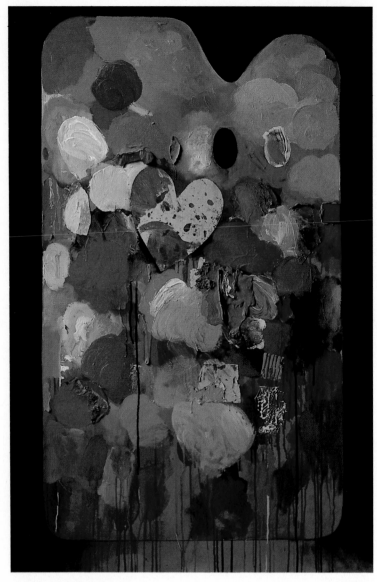

61. Jim Dine (born 1935): *Pleasure Palette*. 1969. Glass, paper and canvas, 152 × 102 cm. (60 × 40¼ in.) Cologne, Ludwig Museum

finished canvas. They attempt to dominate the spectators' mood and dominate the room. Robert Rauschenberg took this a stage further. His Combines employed non-art objects and ephemerae in varied formats, bringing them into the viewer's space and thereby departing from the dominance of the two-dimensionality of painting. This, Kaprow believed, emphasized the fact that the room itself was only another kind of frame and it was inconsistent, he felt, for the room not to

become, in its totality, available as a field for work. He eventually went further, finding the room too confining he worked in the open. He appreciated the contradictions of this stance. In a comparison with the freedom of limitless form, which improvization in jazz allows, he recognized the freedom of the 'limitless' interior space of a canvas such as Pollock's. But it was, as he says in *Assemblages Environments and Happenings*, a different kind of freedom that he was after:

. . . the degree of freedom achieved in impro- vization. These relatively unchanging factors (traditional forms) are felt to be a kind of home base. Yet this may be temporary, a transitional value for today, since a number of younger artists do not find such methods acceptable any longer; they feel them to be excess baggage at least, which often involves needless discords with the past, in which these methods originated. If there are to be measures and limits in art they must be of a new kind.

Thus the progress from canvas to Combine to Assemblage to Environment to Event was on. Kaprow describes it as a logical and inevitable one: 'The line between art and life should be kept as fluid, and perhaps indistinct, as possible . . . The source of themes, materials, actions, and the relationships between them are to be derived from any place or period *except* from the arts, their derivatives and their milieu.' He goes on to list the attributes of the Happening: it should take place over widely varying and changing locales; time should be variable and discontinuous; it should be performed once only; the audience should be eliminated entirely; its composition evolves as a collage of events in certain spans of time and in certain spaces. He was not always con- sistent, his ideas developed; similarly there were others who rejected his definition, but they were all agreed that the idea of a fixed, immovable 'perfect work of art' was literally finished with. Susan Sontag claimed that the most compelling Happenings were ones in

76

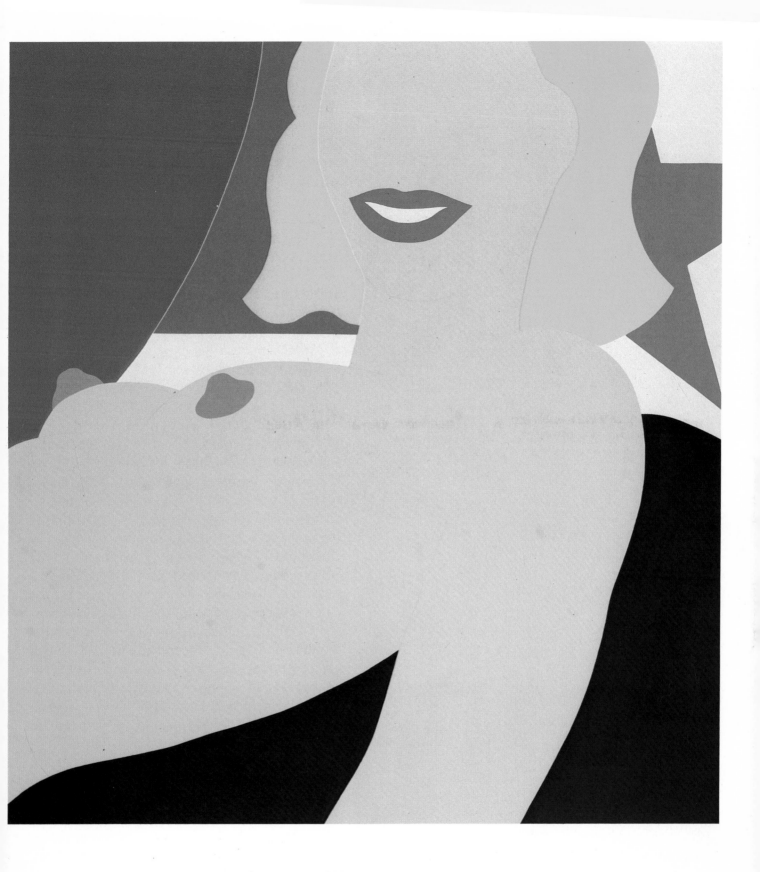

62. Tom Wesselman (born 1931): *Study for First Illuminated Nude*. 1965.
Acrylic on canvas, 116.8 × 109.2 cm. (46 × 43 in.) Washington, Hirshhorn Museum, Smithsonian Institution.
Photo: John Tennant

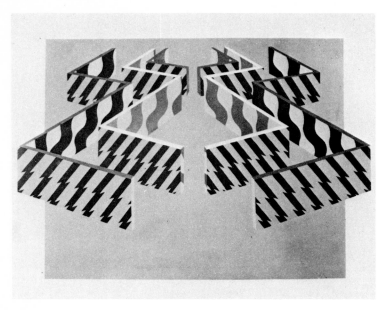

63. Derek Boshier (born 1937): *Vista City*. 1964. Oil on canvas, 304.8 × 196.9 cm. (120 × 77½ in.) Robert Fraser Gallery, purchased by Peter Stuyvesant Fund

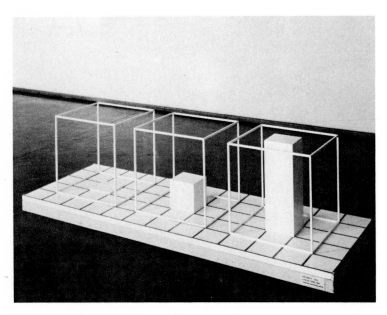

64. Sol LeWitt (born 1928): *3 Part Set 789 (B)*. 1968. Steel with sticky tape, spray-painted, 80 × 208 × 50 cm. 31½ × 82 × 19¾ in.) Cologne, Ludwig Museum

78

which there was an abusive involvement of the audience. In 'Happenings: an Art of Radical Juxtaposition', she catalogues the attributes of Happenings and the milieu in which they took place. Like the Dadaist and Surrealist cabarets they were international and occurred in London, Osaka, Cologne, Stockholm, Milan and Paris, as well as in New York. Initiators were mostly painters, with a leavening of musicians: Kaprow, Jim Dine, Robert Whitman, Red Grooms, Carolee Schneeman, Claes Oldenburg, George Brecht, Yoko Ono, Al Hansen, Dick Higgins, Philip Corner, La Monte Young.

Just as the appearance of the canvas in Abstract Expressionism is secondary to the gesture of creation, so too The Happening marks the abandonment of form in art. The Happening is a descendant of the Dada and Surrealist cabarets, but it is distinguished from them in a number of particulars. The former involved subjection of reason in an abandonment of self to the unconscious. Irrationality and chance were the conditioning agents. The liberation of emotions and passions was held to be part of a profound change of consciousness but this was a reaction against the mechanistic horrors of the first world war. The anarchic tendencies in art, and the drive towards the abandonment of rational control is understandable when one saw what the lunatic fruits of an ordered, rational, controlled society had been. It is not possible to suggest that the Happening developed in response to similar social stimuli, but it is the free play of the unconscious that is their basis. The part that the unconscious played in Abstract Expressionism is recognized; its role was limited to a certain stage in the production of what was still to become an object. The nearest parallel to the unfettered play of the unconscious in the production of a work was in the music of John Cage. Even in his work there was a considerable predetermination of

the area in which chance products of the unconscious might come into play. He labelled this phenomenon 'the purposeful purposelessness', which is another indication that the 'unconscious' act is not a pure one. When Jackson Pollock spoke of the painting as having 'a life of its own,' Mark Rothko of the painting as 'an experience in itself—rather than the depiction of an experience', and Franz Kline of the process of painting being one of 'free association from the start to the finished state', it was of the act, the gesture, the complete surrender of the artist in the moment of making that they were indicating. The actual act of painting in Abstract Expressionism created its own dynamic, it has parallels in both music and literature. The art historians' determination that there was a stylistic and philosophical progression from the creation of chance images—as a result of the unfettered gesture—to the importation of extraneous non-art material in the Assemblage or Combine is not surprising for the collage principle governs both sets of actions. Both were conditioned by a desire to remove the shackles of the picture frame. Hans Richter saw in the desire of man to have tangible objects a need to affirm his physical being by bringing *all* his senses into play: 'Our generation has become so greedy of presence that even the lid of a W.C. is holy to us, we are not satisfied with seeing it pictured, we want to have it altogether, bodily' (*Dada-Art and Anti-Art*).

The principal achievement of Surrealism was the destruction of conventional meanings and the establishment of counter meanings. This is what Sontag called 'radical-juxta-position' (Lautréaumont's fortuitous encounter of a sewing-machine and an umbrella on a dissecting table). Dadaists, wrote Richard Huelsenbeck in *Dada, eine Literarische Dokumentation*, were ' . . . far ahead of their time—people whose peculiar sensibility made

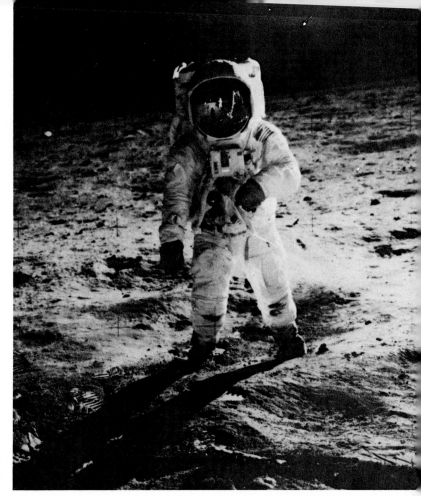

65. Apollo II astronaut Edwin E. Aldrin photographed by fellow astronaut Neil Armstrong on the surface of the moon. 1969. Courtesy of Associated Press

them aware of the approaching chaos and who tried to overcome it . . . creative irrationalists who understood (unconsciously rather than consciously) what the chaos signified . . . they loved the non-sensical without however, losing sight of the sensible'.

The Happening was also designed to stir the audience from its cosy emotional anaesthesia. The displacement of reality in the Happening can be compared with the terror-dream of the Surrealists where a slight displacement of reality is more disturbing than overt horror. The sixties audience was difficult to shock from its complacency: 'Things may have reversed themselves and now it may be the bourgeoisie who shocks the avant-garde', as Brian O'Doherty suggested in the *New York Times*. Susan Sontag recognized that the most remarkable feature of the modern

79

audience was its preparedness and willingness to be shocked:

Inevitably this drives the artist to even greater lengths and even more intense attempts to arouse a reaction from the audience. The question is whether a reaction always needs be provoked by terrorization. It seems to be the implicit consensus of those who do Happenings that other kinds of arousal (for example sexual arousal) are in fact less effective, and that the last bastion of the emotional life is fear.

In *The Theatre and its Double* Antonin Artaud repudiated Western theatre in terms which seem to indicate approval not only for the Happening but other polysensorial sixties events. He criticized it for its tame emotional range, for its cult of masterpieces and for its emphasis on a rigidly pre-determined script. Welcome in alternative art was the equivalent to the pure empty scream of Artaud, the beauty of Genet and the agony of Mishima. If sixties art achieved anything beyond the mere introduction of new media of expression, it was subversiveness: an eventual liberation from the moneyed preciousness and hermetic, self-conscious, petit-bourgeois tastefulness that bedevilled most of the period. To quote Roland Barthes:

'the petit-bourgeois is a man unable to imagine the Other. If he comes face to face with him, he blinds himself, ignores and denies him, or else transforms him into himself . . . This is because the Other is a scandal which threatens his essence.' There is no room for the Other in the petit-bourgeois finite universe of meaning, since the essence of the petit-bourgeois is the universal, endlessly and monotonously repeated mirroring of one and the same existential pattern; the Average elevated to the absolute heights of Universality. The mode of being of the Average is that of the slimy; indeed the prototype of sliminess. The Average ruminates on everything it comes across. It devours, digests and transmogrifies everything it happens to lay its teeth on. Like an Alpine meadow eaten away by a flock of voracious sheep, the world smoothed down by the Average turns into a uniformly dull and dreary heath. Everything imprudently splashed on the treacherously smooth and peaceful surface of the Average disappears never to return; the Average gets its strength, indeed perpetuates its own existence by disintegrating everything around and turning it into its own body, ever growing, never reaching its limits.

It has seemed worth quoting at length, by way of an epilogue, this statement. It is an affirmation of the continued relevance of the sensibility that had one of its great upsurges at the beginning of the sixties, which has, apart from a brief flicker at their end, lain dormant since but needs resurrecting again.

66. Red Grooms (born 1900): *Patriots' Parade*. 1967.
Painted wood, 335 × 254 × 102 cm. (132 × 100 × 40 in.) Stockholm, Moderna Museet

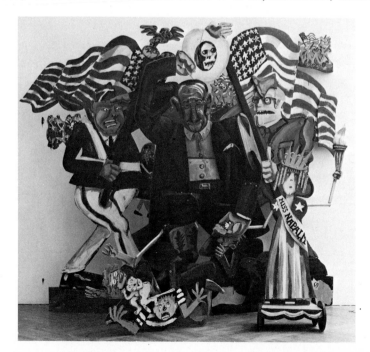

DATE DUE

AUG 2 7 1984		
DEC 1986		
APR 6 1987		
MAR 29 '89		
MAR 2 0 1989		
SEP 1 1 1989		
OCT 0 8 1990		
FEB 2 8 1998		

GAYLORD

PRINTED IN U.S.A.

```
N        Adams, Hugh.
6490        Art of the sixties / [by] Hugh
A27      Adams. -- Oxford : Phaidon, 1978.
            80 p. : ill. (some col.) ; 29 cm.

         QND

            Bibliography: p. 6.
            ISBN 0-7148-1824-0 : £5.95

1. Art, Modern--20th century.   2. Avant-garde
(Aesthetics)   I. Title.

MUNION ME       820723  (  )   820720 CStoC
C000940         MT /EW         A*     82-B5508
                               78-56662
```